WOMEN'S
FASHION
ICONS
**THAT CHANGED
THE WORLD**

50

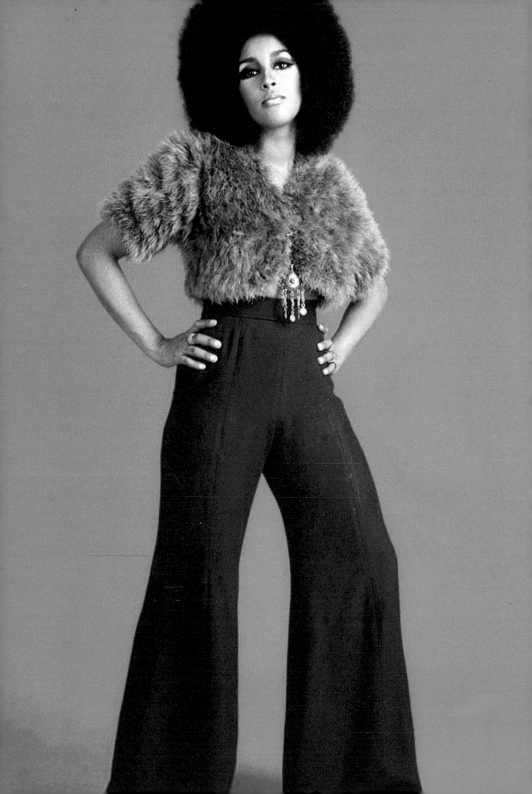

the
**DESIGN
MUSEUM**

WOMEN'S
FASHION
ICONS
**THAT CHANGED
THE WORLD**

50

conran
OCTOPUS

WOMEN'S FASHION ICONS

Marsha Hunt in full 1960s regalia. This photograph was taken in 1968, the year she appeared in *Hair*, when high-waisted flares, a furry bolero, an Afro and shiny shoes were an excellent combination.

INTRODUCTION

What makes a style icon? This book offers no definitive answer, no formula to study. In fact, some of the styles of the women featured here could not be more different from one other – Tina Chow's sharp bohemia compared to the Duchess of Devonshire's twinset and pearls, say, or Jackie Kennedy Onassis's skirt suits versus Nancy Cunard's bangles. But, put together, they do share certain qualities: a flair for fashion, a charisma that marks them out, and a sense of style that shows clothes can, along with many other things, maketh the woman.

If some of the names here are of the household variety – the likes of Madonna, Marilyn Monroe and Kate Moss – others are a little more cult: Marsha Hunt, perhaps, or Betty Catroux. They are all, however, on equal footing – when it comes to style, Debbie Harry, the queen of downtown, is just as royal as the Queen of England.

What we wear is a personal choice, and so is whom you choose to nominate as your style icon. The aim here is to show the rich, diverse and exciting range of women who could fulfil that role. Learning about 50 style icons that changed the world might inspire you to follow their lead, to wear something different – or certainly help you to get dressed in the morning. That is, after all, the very least the great and good of style can do.

Fifties perfection as only Grace Kelly could truly master. This publicity still for Alfred Hitchcock's 1954 film *Rear Window* shows her in the full skirt, tight bodice and high sandals that dominated fashion at the time. Combined with Kelly's blonde good looks, the result is movie magic.

You know your style icon status is indisputable when you become the subject of a fashion film. So it was for American *Vogue* editor-in-chief Diana Vreeland. A documentary, *The Eye Has to Travel*, was released in 2011, directed by Vreeland's granddaughter-in-law, Lisa Immordino Vreeland. It introduced her to a new flurry of fans.

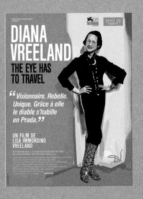

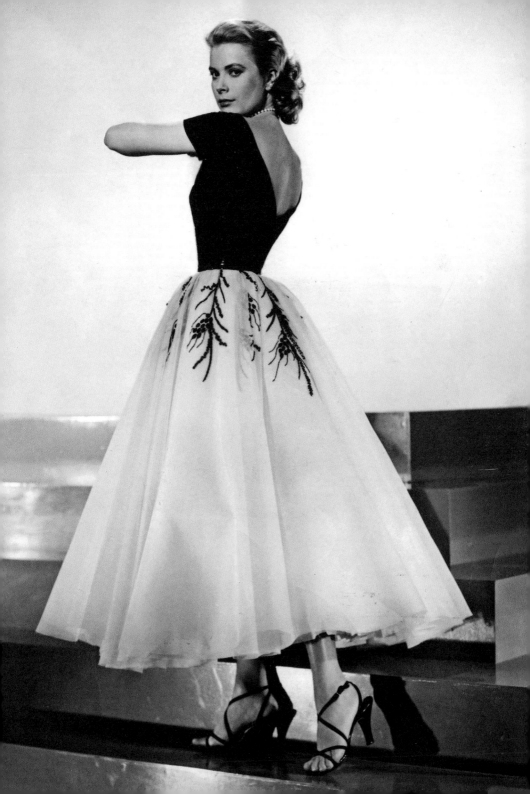

QUEEN VICTORIA

As the head of state for more than 60 years and mother to nine children, Queen Victoria (1819–1901) did not have much time for the fripperies of fashion. But fashion has a lot of time for her. Britain's now-second-longest-serving monarch was responsible for many trends of her own time, including the take-up of tartan, which she wore on visits to Balmoral Castle, her retreat in the Scottish Highlands. Her most notable influences stem from the great romance between her and her husband, the German-born Prince Albert. For their wedding in 1840, Victoria wore a white dress, then unusual because white was seen as a colour of mourning. With the royal approval, the colour took off for brides. The custom for widows to wear black in mourning can also be traced back to the Queen. She wore the colour after Albert died in 1861 and for the rest of her life. With her subjects following suit when their loved ones died, the custom of wearing black garments, and sometimes jet jewellery, increased.

Victoria just made it into the 20th century – she died in 1901 – and she still looms large in the modern era. Her impact on fashion now shows itself in periodic vogues for Victoriana, modern takes on the ornate clothes worn during Victoria's reign. This extends from the 1970s, when there was a fad led by Laura Ashley for rustic pinafore dresses, to Sarah Burton, who drew on the era for her Autumn/Winter 2015 collection for the Alexander McQueen brand. Burton's most explicit nod to Victoria came in 2011, with the decorated bodice of the Duchess of Cambridge's wedding dress. Inspired by the kind that the Queen herself would have worn, it started a Victoria-led bridal trend all over again.

A young and in love Victoria, as captured by the German portrait painter Franz Xaver Winterhalter. This image of her, in the ivory and flower garland associated with a wedding day, was a gift from the Queen to Albert on the seventh anniversary of their marriage in 1847.

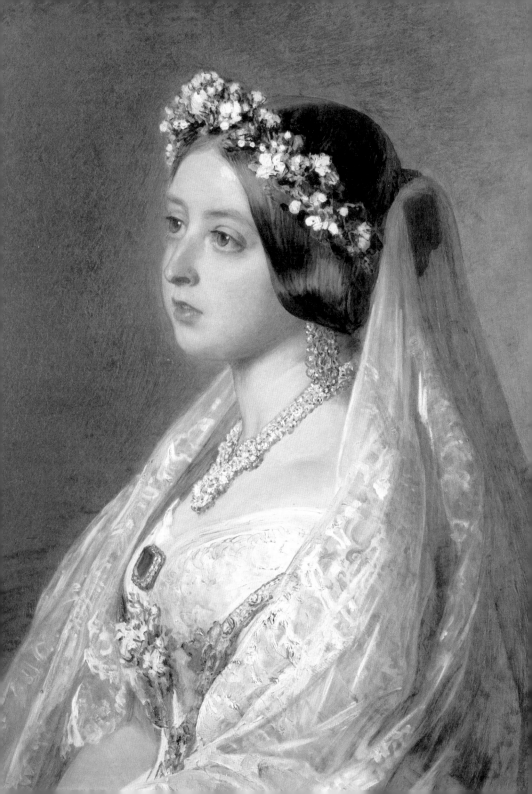

NANCY CUNARD

With an heir to the Cunard shipping business for a father and an heiress mother, Nancy Cunard (1896–1965) was born into high society. It soon became clear that this was not her natural environment. Instead, Parisian bohemia beckoned.

Cunard moved from London to the French capital in 1920 at the age of 24, and met a wave of artists and writers including Aldous Huxley, Constantin Brancusi and Michael Arlen. She wrote poetry and set up the Hours Press, which published work by Ezra Pound and Samuel Beckett. Cunard scandalized her mother by living with a black man, American jazz musician Henry Crowder, and she later campaigned against racism.

Cunard's style explored her creative and rebellious urges. Striking, with pale skin and green eyes, she wore the avant-garde looks of the day. Cunard was one of the first women in London to cut her hair into a bob and wear shorter skirts. She favoured black kohl, red lipstick and a long cigarette holder. Her choice of clothes – sometimes men's suits, sometimes abstract designs by Sonia Delaunay – made sure that she stood out. In 1922 the *Daily Express* described her as someone 'who admires eccentricities in dress and appearance'. A trendsetter, she influenced what other fashion-conscious young women wore when portraits of her were published in the press.

A now-famous 1926 photograph of her by Man Ray shows her penchant for wearing stacks of ivory bangles on both arms. This alone has provided designers and brands, including Gucci, significant inspiration in recent years. They are only picking up what friends of Cunard's had begun: Huxley gave her walk to one of his characters, while Brancusi produced a sculpture inspired by her and Wyndham Lewis sketched her. Cunard was a one-off and other creatives recognize her as such.

If Cunard's time – the 1920s – means that photographs of her are a finite resource, they are all good ones. Here, photographed by Man Ray in around 1926, she is captured in a 'Cunardian' outfit that would have scandalized her contemporaries. An It Girl at the height of her powers.

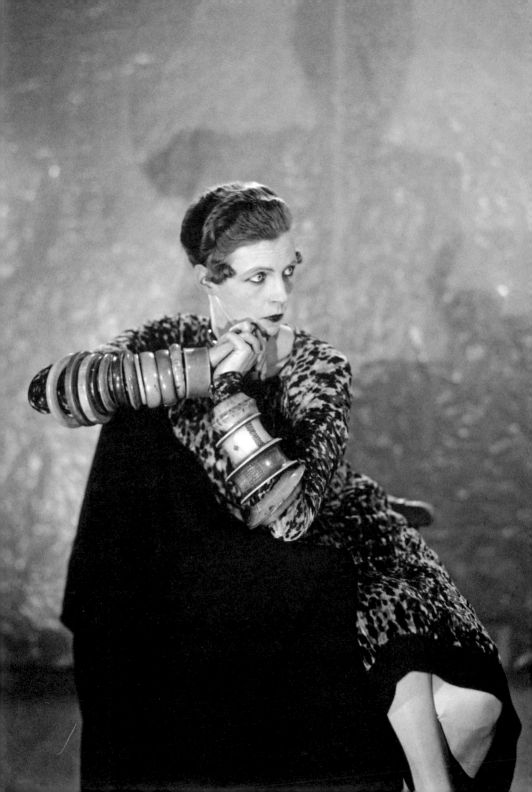

JOSEPHINE BAKER

Dancing at the Folies Bergère in 1926, Josephine Baker (1906–75) wore little more than a bikini top, pearls and – now notoriously – a skirt made of plastic bananas. As Baker was an African-American woman, it was a provocative image, and has remained so in the 90 years that have since elapsed.

Baker's outfit was controversial because it implicitly acknowledged her race – the derogatory association between black people and monkeys being writ large – but it was also attention-grabbing and fearless. As a black woman in the 1920s, dancing on the stage at one of Paris's most famous venues, Baker's very presence broke down barriers. And to do it in such a costume was to force the issue at hand into the limelight, rather than leave it unspoken.

Baker's Charleston, 'Danse de Sauvage', which she performed as the closing number of *La Revue Nègre*, made her a cause célèbre in Paris. The Spanish artist Pablo Picasso called Baker 'the Nefertiti of now', and she certainly had a wardrobe fit for a queen. As well as the banana skirt, she wore opulent fur coats and dripped with diamonds (often presents from admirers). Couturiers including Edward Molyneux and Jean Patou sent her clothes while Paul Poiret modelled a design on her.

The dancer's kiss curls were a trademark and the hairstyles of modern-day pop stars like FKA twigs and Rihanna owe a debt to her (the latter's outfit at the Council of Fashion Designers of America Awards in 2014 was a tribute to Baker). As for that banana skirt, its power is still burning bright. Prada based its Spring/Summer 2011 collection on the Baker look, complete with banana prints, kiss curls and chandelier earrings.

Josephine Baker, in the chevron stripes and cloche hat of her decade, in her adopted city of Paris. Baker was a renowned clotheshorse, whose daywear was almost as eye-catching as the outfits she wore at night while performing on stage at the Folies Bergère.

The Charleston was a dance that went on to define the decade, and Baker was a master of it. Crowds flocked to see the 'American-in-Paris' perform it and, indeed, buy music sheets with her image while they were there. This one, from a performance at the Folies Bergère, dates from 1923.

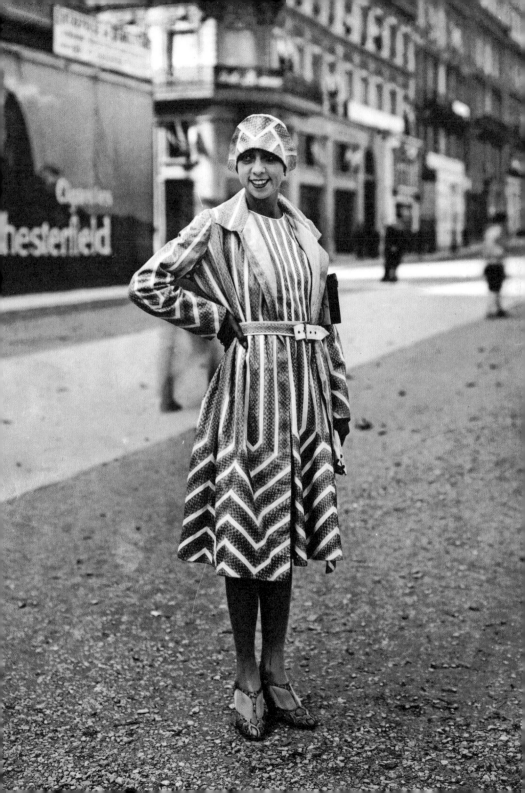

ZELDA FITZGERALD

One fateful day in 1918, F Scott Fitzgerald, then a second lieutenant in the American army, walked into a country club and his life changed for ever. The aspiring writer met 18-year-old Southern belle Zelda Sayre (1900–48) and was blown away. He later described Nicole Diver a character in his novel *Tender is the Night* (1934), famously based on Zelda, as 'a saint, a Viking Madonna'.

Scott and Zelda married two years after meeting. Their look – golden, young, dressed up ready for a party – was inherent to the couple becoming symbols of the Jazz Age. The American writer Dorothy Parker later said they looked like they had 'just stepped out of the sun'. If Scott was the dashing young writer, Zelda was her era's It Girl – and she now represents the 1920s flapper, with her bobbed hair, cloche hats and daring dress sense (a skin-coloured swimsuit she wore as a teenager caused a local sensation).

As is the case with any party girl, Zelda loved fashion. In an arch review of Scott's 1922 novel *The Beautiful and the Damned* that she was asked to write for the *New-York Tribune*, Zelda urged readers to buy the book 'for the following aesthetic reasons', proceeding to list several items of clothing she had her eye on.

It is *The Great Gatsby* (1925) and the female protagonist Daisy Buchanan – again partially based on characteristics of the young Zelda – that has the most resonance in fashion today, as played on film by Mia Farrow in 1974 and by Carey Mulligan in 2013. The flighty rich girl from the South, who steals Jay Gatsby's heart before marrying another of her kind, is a delicate brittle blonde in modern imagination, wearing the kind of finery that befits a woman whose voice, as Scott writes, 'is full of money'. Zelda's hedonistic glamour – whether real or fictional – remains beguiling.

With a short bob, a forthright expression and a fearless gaze that meets the viewer's eyes, Zelda Fitzgerald in 1928 is a flapper *par excellence*. An icon of her own era, and of many to come, this portrait is one that has been pored over by fans since, designers included.

WALLIS SIMPSON

Wallis Simpson (1896–1986), the American divorcée responsible for Edward VIII's abdication in 1936, will always be a controversial figure. But, for the fashion world, that may be a part of her charm. That, and her appreciation of clothes and their transformative powers. Famously, she said: 'I'm not a beautiful woman. I'm nothing to look at, so the only thing I can do is dress better than anyone else.'

And she did, wearing contemporary designers including Hubert de Givenchy, Elsa Schiaparelli and Christian Dior. Her style was immaculate and expensive and often accessorized with opulent jewels. She was notoriously fussy about her clothes. For the funeral of the Duke of Windsor (as the abdicated king became) in 1972, she reportedly had Givenchy stay up all night to alter her veil to the required length. She experimented, too. Simpson wore one of Salvador Dalí's lobster prints for Schiaparelli, and she also owned a Paco Rabanne designed spacesuit.

Simpson died in 1986, but she has continued to influence modern designers ranging from Roland Mouret to Stella McCartney. Interest has increased since the Madonna-directed 2011 biopic, *W.E.*, with costumes by Arianne Phillips. Mouret designed a Simpson-esque dress the same year and neatly summed up her appeal in a comment to a newspaper.
'You can't work in fashion and not be inspired by the life and wardrobe of Wallis Simpson,' he said. 'Love or hate her, the world is still obsessed by that woman.'

Simple, chic and luxurious are words that might sum up the Duchess of Windsor in this 1937 portrait. The clean lines of the shift dress and neat sequinned jacket were part of a pulled-together silhouette she returned to throughout her life, most of which was lived in the glare of the media spotlight.

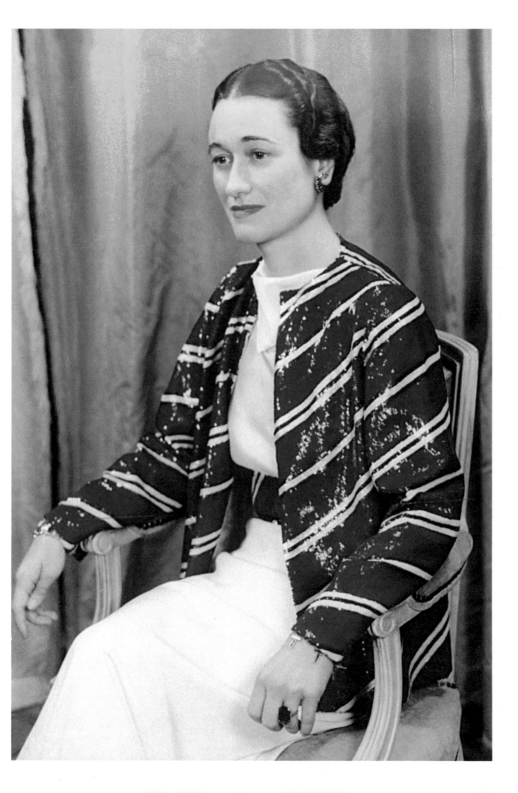

KATHARINE HEPBURN

When launching her new brand Hillier Bartley in 2015, designer Luella Bartley nominated Katharine Hepburn (1907–2003) as one of its muses. 'Hepburn had always eluded me,' she told the *Financial Times*, 'but now I felt like I wanted to be that elegant, louche woman.' Elegance and Hepburn go hand in hand – especially elegance of the grown-up, independent kind.

This attitude is typified in the actor's association with trousers, in an era – the 1930s and 1940s – when women more commonly wore dresses. Hepburn played the game in some roles – as Tracy Lord in ruffles for 1940's *The Philadelphia Story*, for example – but, as *Time* magazine stated, her 'favourite outfit in real life is a man's suit of clothes'. Contemporary photographs of Hepburn show this to be the case. Long, rangy and lithe, she wore a uniform of a pair of khakis and a white shirt, with minimal make-up. Strikingly modern, Hepburn – the daughter of a feminist campaigner – saw wearing what she wanted as her right. When studio executives tried to discourage her from trousers, she stripped down to her underwear to make a point. And, always with a quip to hand, she turned the tables on male critics: 'Anytime I hear a man say he prefers a woman in a skirt, I say, "Try one. Try a skirt,"' she famously said.

Hepburn has long been a symbol of American style – active, free-spirited, sartorially speaking her mind. Her importance to the industry was formally acknowledged in 1985, when the Council of Fashion Designers of America presented her with its Lifetime Achievement Award.

In an image to make her many fans swoon, here is Hepburn in her pomp with all the subtle but elegant symbols that showed her rebelling against contemporary ideals of femininity. A trouser suit, flat shoes, little make-up and cigarette are here, along with telltale cables to signify her natural environment, a film set. The year 1938 was clearly a good one for the star.

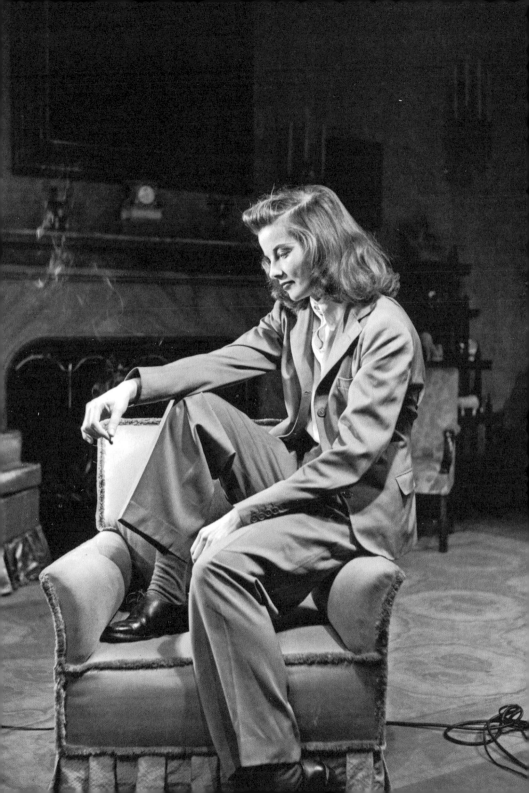

THE DUCHESS OF DEVONSHIRE 1940

The narrative of the Mitford sisters comes packed full of fashion references. Nancy was clothed by Christian Dior, Diana was lauded as a famous – if controversial – beauty and Jessica ('Decca'), who defected to America and communism, was the rebel. Deborah ('Debo'), the youngest sister who eventually became a duchess, is perhaps fashion's favourite.

The last of the six sisters to 'come out' – the term used for debutantes' introduction to society at the age of 18 – Deborah Mitford (1920–2014) picked her moment: 1938, the last season before the outbreak of the Second World War. In her 2011 memoir *Wait For Me!*, Debo describes evening dresses run up by the housekeeper with typical gracious pragmatism: 'Although I envied the girls with dresses by Victor Stiebel, mine were always unique.' In a photograph taken around this time, Debo is shown in a picture-perfect white frock and with bobbed hair. The round blue eyes put her Mitford genes beyond doubt.

At a party during her debut season, Debo met fellow 18-year-old Andrew Cavendish, whom she went on to marry. In 1950 they became the Duke and Duchess of Devonshire and moved into Chatsworth House, Cavendish's family seat and stately home in Derbyshire. It was there that the Duchess became the last word in country chic, wearing clothes picked up from a wide variety of sources. 'After agricultural shows, Marks & Spencer is the place to go shopping, and then Paris,' she wrote. 'Nothing in between seems to be much good.' The Duchess's style consisted of tweed jackets, smart blouses, pearls and coiffed hair, a timeless combination that she wore until her death in 2014 at the age of 94. Her fashion status is boosted by having passed down those blue eyes – the supermodel Stella Tennant is her granddaughter.

Country style personified, the Duchess of Devonshire found her formula early on and stuck with it. This image, taken in 1940 when she was still merely 'Debo' Mitford, includes all the elements: tweed, sensible shoes and gloves, accessorized with a dog. Change the backdrop and it could almost have been taken at any time over the past 50 years.

There is nothing like a portrait by a famous artist to show how established one is in British society. This 1959 painting of the Duchess, by Bloomsbury artist Duncan Grant, does that, as well as demonstrating that she has much more important things to do than sit for a portrait. Her beloved hens in the background speak volumes, as do the folded arms.

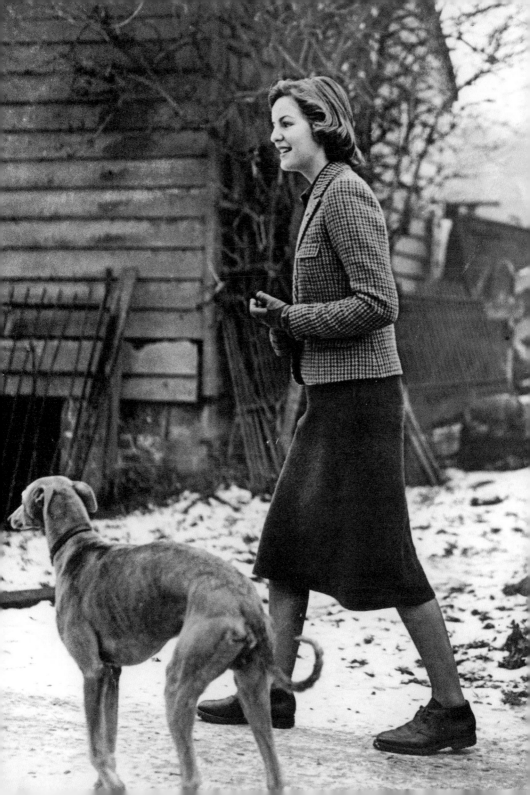

MARLENE DIETRICH

While her mannish suits and metallic gowns put her on best-dressed lists for decades, Marlene Dietrich (1901–92) apparently could not have cared less about fashion. In a newspaper interview in 1960, she declared, 'If I dressed for myself I wouldn't bother at all. Clothes bore me,' and proceeded to wax lyrical about the wonder of men's jeans.

If such pronouncements threaten to undermine fans' worship of this giant of androgynous glamour, they have only to look again at photographs of Dietrich in the 1930s to feel heartened. In her suit, blouse and top hat, holding that very period-appropriate accessory, the cigarette, the German star was a true professional. She knew that playing with these symbols of the opposite sex gave her something different in a sea of film stars in gowns. 'I am, at heart, a gentleman,' she famously quipped.

Dietrich's breakthrough role was as cabaret singer Lola-Lola in 1930's *The Blue Angel*. Her move from Berlin to Hollywood was swift and she was cast as a *femme fatale* in films including *Morocco* (1930) and *Shanghai Express* (1932). The former was sartorially notable for Dietrich's outfit of man's suit and top hat, and scandalous for the scene in which the star kisses another woman.

When her film career faded in the 1950s, she began to work in cabaret. Her look was carefully constructed for her stage shows, which were so popular that she could charge up to $30,000 a week. Christian Dior and Cristóbal Balenciaga were favoured designers, and Dietrich had clothes made for her 'unusual shape – broad shoulders, narrow hips'. As Dietrich herself said, 'I dress for the image.' Calculated, clever and disinterested, perhaps, but undeniably effective.

An elegant pose from Dietrich, as a star of the silver screen in 1942. Her ability to cultivate an image of androgynous sex appeal was one that stood her in good stead over throughout a career in film and cabaret that lasted 30 years.

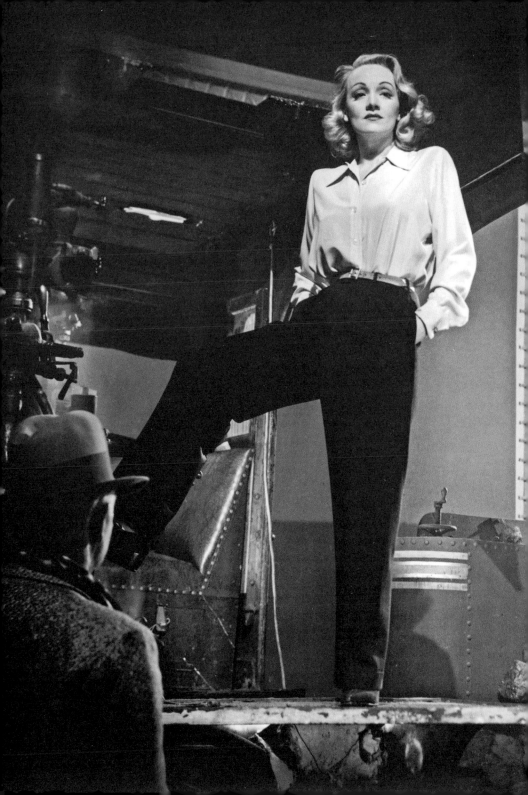

GRACE KELLY 1954

Starring in *Rear Window* (1954), *Dial M for Murder* (1954) and *To Catch a Thief* (1955), Grace Kelly (1929–82) was the archetypal Hitchcock blonde. The American actor, with her coiffed hair, classic good looks and haughty stare, fulfilled the director's desires for immaculate – sometimes billed as 'icy' – leading ladies. Outfits including full-skirted dresses and smart skirt suits, always polished and neat, summed up a mid-1950s ideal of a woman, and Kelly wore them well.

Designers from Alexander McQueen to Miuccia Prada have paid tribute to the Hitchcock heroine, while the outfits that Betty Draper (played by January Jones) wears in early episodes of the American television series *Mad Men* nod to Kelly's influence on real women during the era. The actor had the kind of reach that brands love. When she was photographed with a Hermès bag in 1956, held across her stomach to hide her pregnancy, the bag became a star. Rechristened the 'Kelly' in 1977, it remains the leather house's bestseller.

Kelly famously gave up her stardom in 1955, at the age of 25, and went from being America's sweetheart to Monacan royalty. She married Prince Rainier of Monaco the following year, in what was referred to by the press as the 'wedding of the century', watched by an estimated 30 million people on television. Despite its royal associations, Kelly's wedding dress bore the vestiges of Hollywood. It was dreamed up by Metro-Goldwyn-Mayer's costume designer Helen Rose, made by the wardrobe department and paid for by the studio. One of the most influential wedding dresses ever, this was still the case 55 years later. When Kate Middleton married Prince William in 2011, she wore an Alexander McQueen dress, created by Sarah Burton, which paid homage to Kelly's, with long lace sleeves and a neat bodice. The takeaway? Kelly's mix of class and chic respectability is one that never gets old.

A director and his muse. Here is Grace Kelly being met off the train at Cannes railway station by Alfred Hitchcock in 1954. The iconic Hitchcock blonde starred in *Dial M for Murder* and *Rear Window* for the director that year – it is no wonder that he was so gentlemanly.

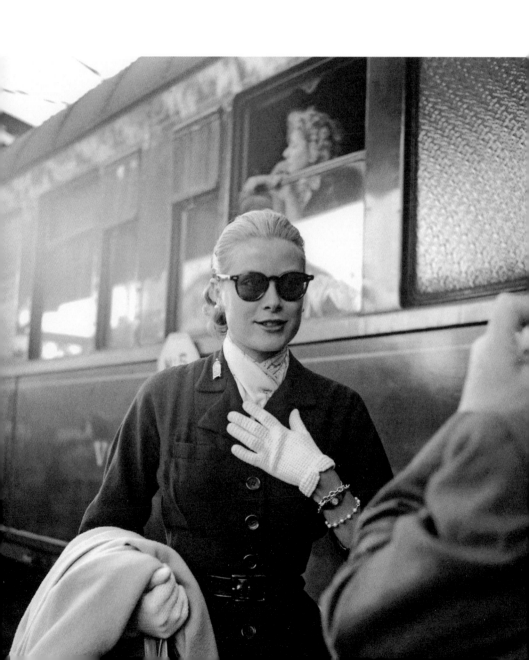

AUDREY HEPBURN

Audrey Hepburn (1929–93) made her name as an actor in the 1950s and 1960s, and she now stands for a particular type of mid-century elegance. With her slight figure and gamine looks, she was the antithesis of Marilyn Monroe's curves and sex appeal, but her own charm came from a certain grace, the kind that can turn a simple little black dress (LBD) into movie magic.

Hepburn's big break came in 1953 with *Roman Holiday*, and her early films saw her dressed in the fashions of the time – flared skirts, ballet flats and eyeliner flicks. It was 1961's *Breakfast at Tiffany's*, in which Hepburn starred as party girl Holly Golightly, that confirmed her fashion pedigree. The dress she wears in the title sequence – long, black, slinky – is often called the most famous LBD of all time, and a version of it sold for nearly £500,000 at auction in 2006.

While the dress seen in the film was made by costume designer Edith Head, the original it was based on was the work of Hubert de Givenchy, the designer who became Hepburn's most frequent collaborator. Givenchy worked on Hepburn's image from 1954's Oscar-winning *Sabrina* onwards, and once told *Vanity Fair* that the star 'gave a life to the clothes'. The two continued to work on Hepburn's wardrobe – on and off screen – throughout her career. Givenchy designed clothes for her to wear in *Funny Face* (1957), *Charade* (1963) and *How to Steal a Million* (1966) – all classics to Hepburn's fans, who love the way she wears the designer's mix of clean lines and femininity.

Hepburn's icon status is now gold-plated. In 2015 London's National Portrait Gallery staged *Audrey Hepburn: Portraits of an Icon*, an exhibition of photographs, including an array of magazine covers from throughout her life and off-duty shots of her in black polo-neck, trench coat and bunches. Queues went out the door.

Hepburn was a woman of such exquisite elegance that even a backdrop of a Rome junk shop in 1955 becomes chicer through her mere presence. The combination of little black dress, doe-like eyes and side-swept fringe is her formula. Timeless, yet perfectly mid-century too.

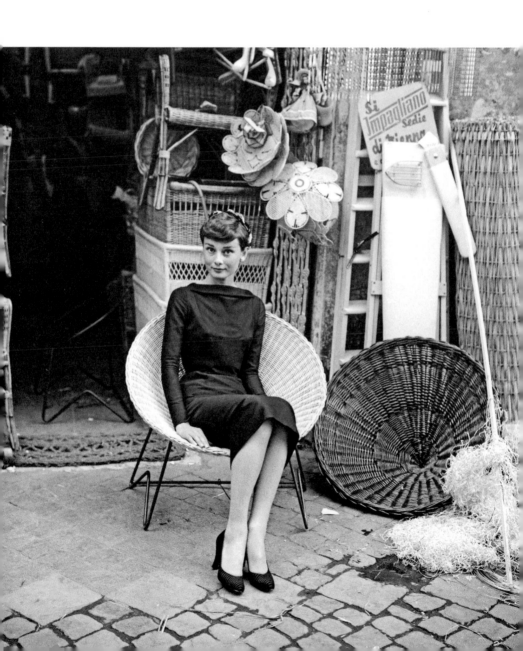

MARILYN MONROE 1960

Marilyn Monroe's pop-culture footprint goes far beyond fashion – but many of her key moments can be traced back to clothes. There is September 1954, filming 14 takes of *The Seven Year Itch* (1955) in Manhattan, with a white dress blowing upwards as she stood on a subway grate; or the almost transparent dress she wore to sing happy birthday to President John F Kennedy in 1962. And the pink dress and diamonds in 1953's *Gentlemen Prefer Blondes*. Many of these outfits were made by costume designer William Travilla, a man who later dismissed *The Seven Year Itch* number as a 'silly little dress'. It was sold at auction in 2011 for £2.8 million.

During the 1950s Monroe (1926–62) was the alpha sex symbol, smouldering through films including *How to Marry a Millionaire* (1953), *Niagara* (1953) and, of course, *Some Like It Hot* (1959). Fashion prefers her more downbeat – as Rosalyn in 1961's *The Misfits*, where she wears jeans and a white shirt, or off-duty. Much-studied images of Monroe include those taken by Eve Arnold between takes on filmsets, and those by George Barris, of Monroe curled up in a chunky sweater on a Californian beach. These images inspired Max Mara's Autumn/Winter 2015 collection. Gigi Hadid, sometimes called a modern Marilyn, starred in the campaign.

Marilyn's image was, of course, immortalized in screen prints by Andy Warhol, which he made in the four months after her death in 1962, using a publicity still from *Niagara*. This Marilyn is now as much an iconic image of the 20th century as the woman herself, and fashion plays with it accordingly. Gianni Versace used Warhol Marilyns on designs for his Spring/Summer 1991 collection and Dries Van Noten continued the homage for his Spring/Summer 2016 menswear collection. An image of an image is one of the ways in which Marilyn lives on.

Marilyn caught in a private moment, away from the flashbulbs that punctuated the life of a movie star. Here, on the set of *The Misfits* in 1960, photographed by Eve Arnold, she is less an icon and more a woman. *The Misfits* was to be her last completed film.

Monroe as her public saw her – platinum blonde hair set, glossy red mouth laughing. It was photographs like this that Andy Warhol used for his famous *Marilyn* series. The resulting screen prints are among the most famous images of twentieth-century art.

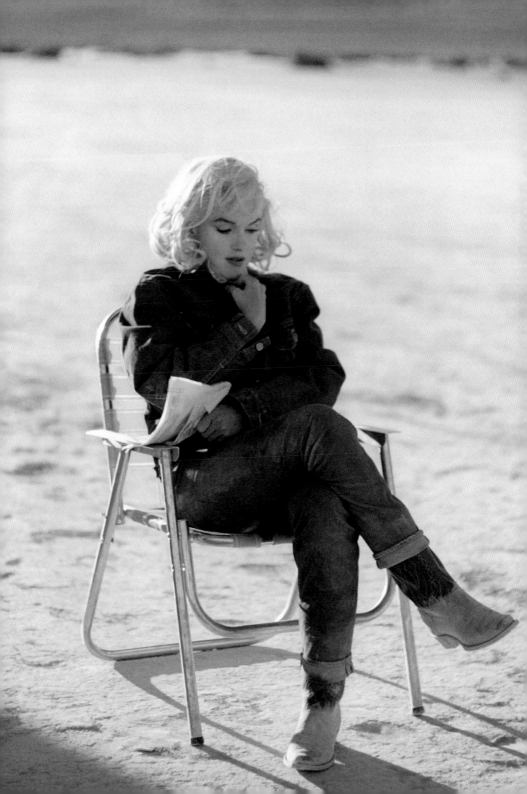

JEAN SHRIMPTON

1961

At the start of her modelling career, Jean Shrimpton (1942–) described herself as 'waifish, coltish and cack-handed'. David Bailey, the photographer who would play a significant role in her career and life, interpreted things rather differently. Watching her in a shoot for rival photographer Brian Duffy, he said simply, 'I looked in his studio and saw this vision.'

This encounter in 1960 had a hand in shaping the decade to come. The two became an item, and the pictures that Bailey took of Shrimpton represented a new generation. Appropriately, they were often for the 'Young Idea' section of *Vogue*. In 1962 the duo went to New York to work on what would become a classic fashion shoot, 'Young Idea Goes West'. The reportage-like images of the teenage Shrimpton – photographed carrying a teddy bear around Manhattan, all doe eyes, angular elbows and windswept hair – created waves in the still-stiff world of fashion magazines. Shrimpton's career was now on the up. Often regarded as the first-ever supermodel, she was soon the recipient of a nickname, 'The Shrimp', and, after leaving Bailey, an actor boyfriend in the shape of Terence Stamp.

Shrimpton retired from modelling in her thirties but an image of her in a simple sweater at Bailey's family home, taken in 1961, is a fine example of the elegant lines and eyeliner that remain a powerful influence today. She also played a part in fashion history. Wearing a miniskirt to the notoriously conservative Melbourne Cup horse race in 1965 was such a scandal that it provoked headlines around the world. Shrimpton's unwitting message? The young ideas had arrived, and they were here to stay.

With a tilt of the head and just the right chunkiness of knit, Shrimpton's mixture of effortlessness and elegance is plain to see here. This shot of her by David Bailey, taken in his mother's hallway in 1961, is now part of a decade's fashion folklore. Many photographers have tried to replicate it since, but the original is still the best.

TWIGGY

There are some figures who transcend even the style icon tag and Twiggy (1949–) is one of them. She is less a reference to drop and more a face to define a moment in time. With her big eyes, even bigger eyeliner, boyish crop and – as the nickname suggests – that slight, rangy body type, she *is* 1960s London.

Born Lesley Hornby in northwest London in 1949, her rise as a model was swift and certain – with 1966 being the key year of the decade when it all happened. Aged 16 and weighing just 6$\frac{1}{2}$ stone (91lb/41kg), she cut her hair in January and by February was in the *Daily Express*, dubbed 'the face of '66'. Twiggy fever hit fashion – her girlish figure and young spirit felt new and right following the 1950s, a decade where femininity had been seen as grown-up and ladylike. By 1967 the model had appeared on 13 *Vogue* covers and was so (figuratively) huge that a visit to America made the news and prompted the *New Yorker* to publish a feature about her that was nearly 100 pages long. At the height of her fame, she charged £800 a day for modelling.

While Twiggy could not be called the first supermodel – she herself graciously gives that accolade to her heroine Jean Shrimpton – she was perhaps the first model that the man on the street might be able to name, a kind of Kate Moss of her day. She has continued her associations with fashion and has been a regular in adverts for the UK high-street retailer Marks & Spencer since 2004. If, once, Twiggy was a face of British fashion, she is now an institution.

As the 1960s progressed, Twiggy capitalized on her fame and become a brand. Here she is in 1967 modelling her own line of clothes, complete with hangers that feature her image. Dolls of the model were also produced at the height of her fame.

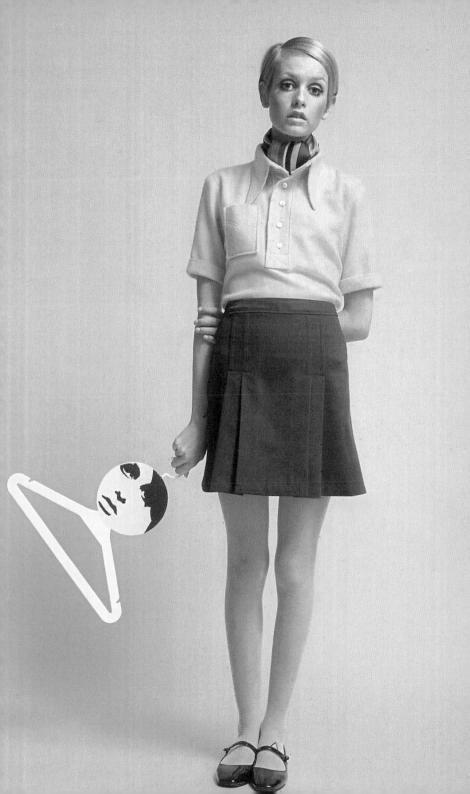

PEGGY GUGGENHEIM

The address book of Marguerite ('Peggy') Guggenheim (1898–1979) must have been like a who's who of art in the 20th century. She was associated with everyone from Man Ray to Marcel Duchamp, Wassily Kandinsky to Paul Klee, and helped these artists become recognized by putting on exhibitions of their work, first in London and then in Venice, where she opened a museum in 1949.

As might be expected of a woman who surrounded herself with people working at the outer reaches of artistic expression, the curator's dress sense was eclectic and unusual. Accessories were a weakness, with extravagant hats and oversized cat-eye glasses being particular favourites. She also famously wore mismatched earrings, years before Nicolas Ghesquière put similar designs on the Louis Vuitton catwalk. With one by Yves Tanguy and the other by Alexander Calder, she quipped that the affectation was 'in order to show my impartiality between surrealist and abstract art'. Guggenheim also wore clothes by designers at the top of their game – Elsa Schiaparelli and Paul Poiret were favourites. She was easily able to indulge a habit for designer clothes: part of a wealthy American family, her uncle was Solomon R Guggenheim, who established the famous museum in New York.

If Peggy Guggenheim's life was coloured by creatives, her legacy – in style, at least – is of someone who knew exactly what she wanted to wear, and the rest of the world be damned. This spirit gained new relevance with the release of a documentary on her life, *Peggy Guggenheim: Art Addict*, in 2015, directed by Lisa Immordino Vreeland, granddaughter-in-law of the famous editor of American *Vogue*.

'The ayes have it' – they certainly do with shades like these. Here is Peggy Guggenheim on a gondola in Venice, looking every inch the queen. In 1953 she ruled the art world of the Italian city, and was known as much for her eye for modern painters as she was for her happily eccentric style.

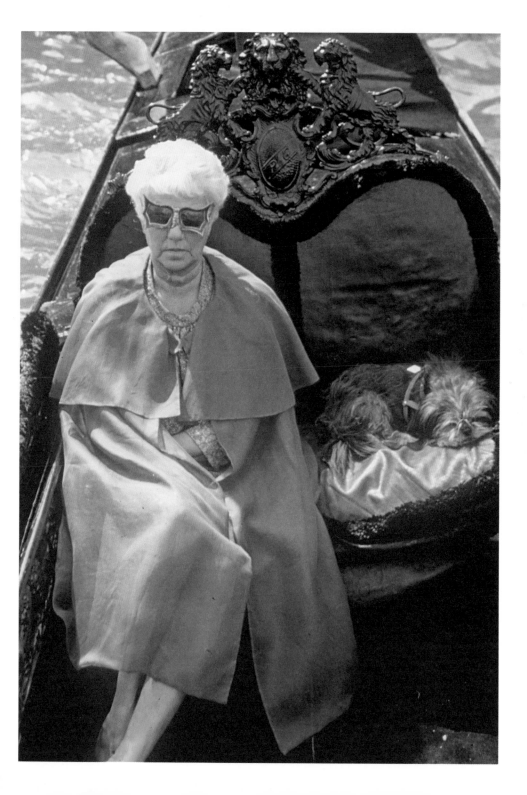

MARSHA HUNT

Marsha Hunt (1946–) contributed only two lines of dialogue to the 1968 London production of the musical *Hair*, but the actor's impact on the zeitgeist was much more significant. Her halo of natural curls and penchant for dashikis made her, in the UK, a poster girl for the Black Power movement. Thanks to her refusal to treat her hair so that it mimicked Caucasian ideals of beauty, her Afro became a political symbol. The poster for *Hair* – the story of countercultural youth – featured an image of her in silhouette, complete with Afro.

Hunt was originally from Philadelphia and moved to London in a pivotal year, 1966. She was soon at the heart of the bohemian scene in the capital, first working as a singer. An affair – and a daughter – with Mick Jagger followed, and it is believed that he wrote 'Brown Sugar' (1971) about Hunt.

For the Christmas 1968 issue of *Queen* magazine, Hunt was photographed with baubles decorating her Afro, making her the first black model to appear on the magazine's cover. A shoot for *Vogue* by Patrick Lichfield the next year led to probably the best-known image of Hunt – naked, with her legs folded into a perfect triangle. The shot was destined for the cover but, at a time when racial equality was still in flux, Hunt's beauty and style remained controversial things to celebrate. The images were published inside the magazine instead.

While Hunt has since become a writer, her life in the 1960s continues to define her place in popular culture. The Lichfield portrait is now famous and the interest in her personal life remains. In 2012 Hunt sold letters that Jagger wrote to her in 1969. They fetched more than £187,000.

Hunt in 1968 is a woman but also a symbol of a change in the times, an era when race relations, as they had existed, were being eroded. Clothes were central to her involvement, as her dashiki and Afro – both symbols of black style – demonstrate.

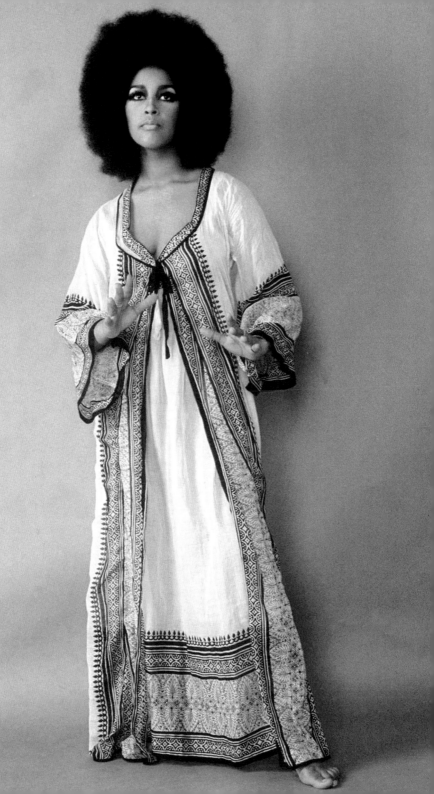

TALITHA GETTY

Sometimes a style icon's significance comes from a moment in time, and so it is with Talitha Getty (1940–71), who was snapped with her husband, John Paul Getty, by Patrick Lichfield on a rooftop in Marrakech in 1969. Wearing an embroidered robe, harem pants and white go-go boots, hair wild, eyes kohl-lined, she was – and remains – a vision of late-1960s bohemia.

Talitha Getty's look was shaped by the circles in which she moved. Getty – née Pol – was brought up in the artistic elite (her step-grandfather was the British painter Augustus John) and married her husband, an oil industrialist, in 1966. Her wedding outfit consisted of a white miniskirt and a hooded coat, trimmed with mink.

Once they were married, the couple's Marrakech home was soon full of friends, including Mick Jagger and Marianne Faithfull, Anita Pallenberg and fashion designers Ossie Clark and Yves Saint Laurent. It was the last whom Getty particularly entranced. He later said that when he met her his 'vision completely changed'. This can be seen in Saint Laurent's collections – which move from the neat modernism of the mid-1960s to a looser, loucher feel, with his 1940s-inspired collection in 1971 and the Russian collection five years later.

Getty's moment was short-lived – she died of a heroin overdose in 1971, at the age of 30 – but it has cast a long style shadow. She had her part to play in one of the most influential designers of the 20th century discovering his eclectic side, and the ripples of that 1969 image continue now. With bohemian fashion a mainstay in our wardrobes, forget the likes of Sienna Miller. Getty on a rooftop is the original.

Originally used in *Vogue*, Patrick Lichfield's 1969 portrait of Talitha Getty with her husband shows the socialite in her prime. The image would go on to inspire several generations of women determined to define – and certainly wear – the bohemian look. Getty's eyeliner and kaftan are a good place to start.

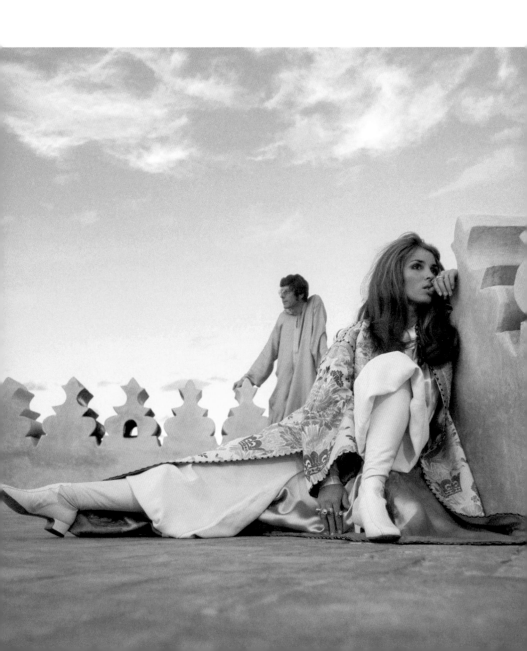

BRIGITTE BARDOT 1969

Described by the French President Charles de Gaulle as 'the French export as important as Renault cars', the subject of an essay by Simone de Beauvoir and a book by Françoise Sagan, Brigitte Bardot (1934–) can be partly defined by her nationality. She is a particular brand of French chic personified: effortless, insouciant and sexy.

The former dancer began to model in the 1950s. Her second cover for *Elle* in 1950 – published when she was 16 – brought her to the attention of a generation of young French women more accustomed to seeing women like their mothers on the covers of fashion magazines. Bardot represented something they could identify with: the *jeune fille*.

By the age of 21, Bardot had starred as the temptress Juliette in *And God Created Woman* (1956), directed by her then husband Roger Vadim. Bardot – 'BB', as she became known – was now the archetypal sex kitten. This was augmented by photographs of her, with long blonde hair and eyeliner, frolicking on the beach in the south of France, or visiting Picasso in his studio in 1956, wearing a full-skirted printed dress with a tight bodice, ballet flats and a high ponytail. Part wide-eyed ingénue, part smouldering siren, Bardot is a study in opposites aligning.

Although she retired in 1973, and now concentrates on campaigning for animal welfare, Bardot's place in fashion remains. Louis Vuitton's Autumn/Winter 2010 collection was in part based on her and, in the summer of 2015, there was a fad for loose blouses cut across the shoulders, just the thing for walking down a beach in Saint-Tropez. The garment's name? The Bardot top.

The curve of a neck, a pout and those feline eyes… Bardot was as much about physical attributes as she was about style. She knew how to make clothes work for her, as this 1969 image shows. Rolled-up sleeves, square neckline and a pair of stilettos are all that is needed when you are Bardot.

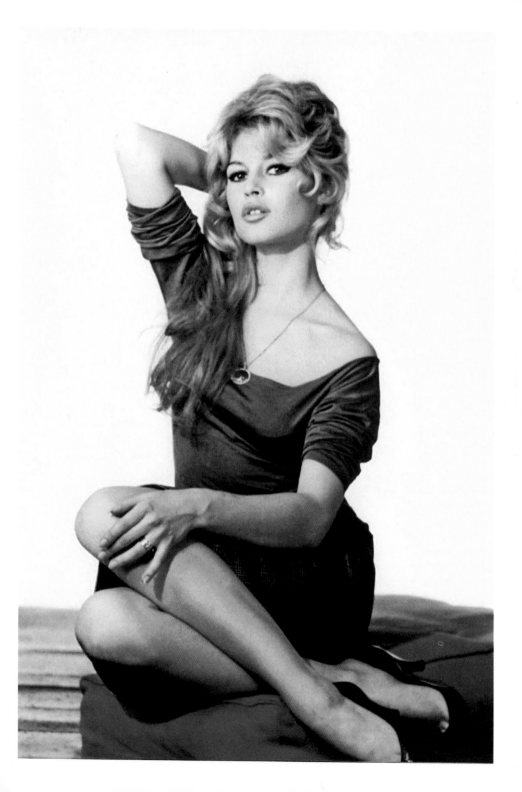

FRANÇOISE HARDY

It could be said that without Françoise Hardy (1944–) Alexa Chung might not exist – or at least not in her current incarnation. Hardy, a French singer and actor, was not only a Chung-like It Girl of her day, but Chung has credited Hardy as her personal style icon. There is, to the initiated, a direct line between the two women's soignée but rock-'n'-roll style.

Hardy's era was the 1960s. Her 1962 single 'Oh Oh Chéri' became a hit due to its B-side, 'Tous les garçons et les filles', selling over two million copies. She went on to compete in the Eurovision Song Contest for Monaco in 1963. Hardy, in her late teens in the early 1960s, represented a new generation of Gallic ideal, dressed in simple striped sweaters with fringed locks and lashings of eyeliner. This was captured on her record covers, which feature her wide-eyed and carrying an umbrella or chewing on a daisy. While unapologetically pop, these images seduced the rock stars of the day. Hardy features in a poem by Bob Dylan, and Mick Jagger described her as his ideal woman.

These days, Chung is not the only one to look to Hardy. Nicolas Ghesquière, the artistic director at Louis Vuitton, sees her as part of a tradition of chic Frenchwomen that also includes his friend, and Hardy lookalike, Charlotte Gainsbourg (the daughter, incidentally, of Jane Birkin). The ultimate compliment, however, perhaps comes from slightly outside fashion. In Wes Anderson's 2012 film *Moonrise Kingdom*, the 12-year-old heroine, Suzy Bishop (played by Kara Hayward), is a Hardy fan, playing her records and studying the covers endlessly. In Bishop's eyeliner alone, Hardy's influence burns bright.

This 1969 image of Hardy was snapped in Milan but smacks of the Gallic chic she became known for. See chopped fringe, eyeliner, the decadence of a fur coat and the frankness of her stare. Add a book for a touch of Left Bank intellectualism and *voilà*, la jeune fille of an era.

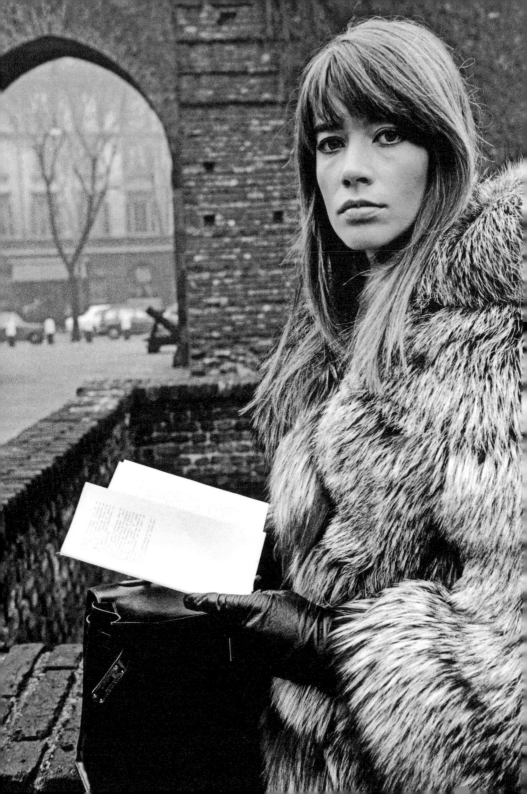

BETTY CATROUX

Describing his first impressions of his great friend Betty Catroux (1945–), designer Yves Saint Laurent said she was 'just what I love. Long, long, long'. In Catroux, with her long legs, long blonde hair and angled, cheek-boned face, Saint Laurent had found the yin to his yang. At the time, she often wore short black skirts and knee socks, with her hair in a plait. 'He liked my physique and he made a parallel with it and his own,' she later recalled of their first encounter at a Paris nightclub in 1967. The designer often called her his 'twin sister'.

Catroux began modelling for Coco Chanel at the age of 17, in the early 1960s, after a recommendation from a friend of her mother's. It was there that she learned to be an effective muse. Speaking to *Interview* magazine in 1975, she said of Chanel that 'everybody wanted to be her favourite; it was as if she was a man'. Saint Laurent, then, provided the platonic male gaze, and Catroux, in turn, looked wonderful in his clothes. Whether wearing his now-classic Le Smoking trouser suits, or an item from the Safari Collection of 1968, she brought her lanky, rakish charm – qualities that only added to their appeal. Throughout the 1960s and into the 1970s Catroux was principal among Saint Laurent's coterie of muses, appearing with him at public events and holidaying at his villa in Morocco.

Catroux has stayed faithful to Le Smoking, first created in 1966, throughout her life and continues to wear it today. Still a front-row regular at Saint Laurent shows in Paris, she is now a hero of a new generation of young women who love the mannish tailoring that the design symbolizes. Speaking to *Porter* magazine in 2014, she conceded that she had 'helped inspire the androgynous trend today'. Of that there is little doubt.

Photographed for *Vogue* in 1970, Catroux's elongated lines are complemented by the long shapes and shiny surfaces in her apartment. A greyhound adds to the elegance. Saint Laurent's muse seemed to exist only in such rarefied surroundings – anywhere else is simply not chic enough.

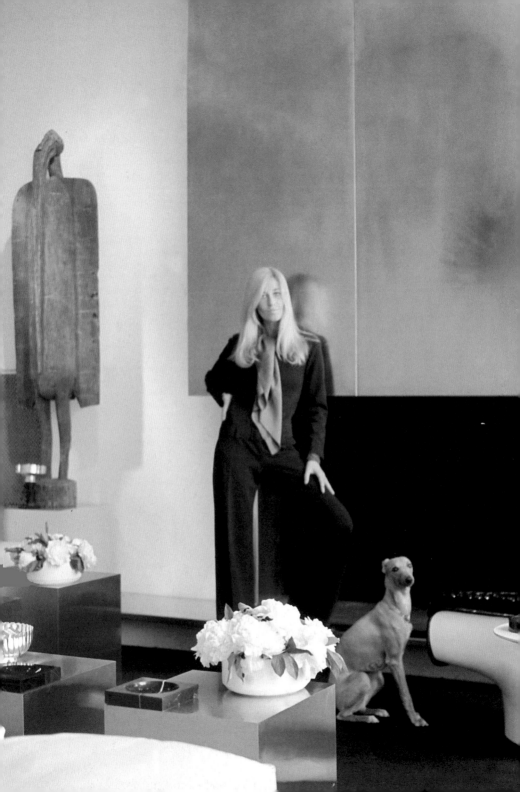

Described as a 'model-actress-whatever with decadence running thick in her blood' in *Ready, Steady, Go!*, Shawn Levy's 2002 book chronicling the 1960s in London, Anita Pallenberg (1944–) was a principal It Girl of the decade. As the girlfriend of first one of the Rolling Stones, Brian Jones, and then another, Keith Richards, she was the archetypal rock chick. Her shag of blonde hair, slick of eyeliner and wide smile did part of the work. A penchant for boho layers – Afghan coats, feather boas, low-brimmed hats, flower prints and stacks of bangles – sealed the deal.

Originally from Rome, the daughter of an Italian artist and a German secretary, Pallenberg studied graphic design and worked for *Vogue* photographer Gianni Penati before becoming a model. She met Jones in 1965 backstage at a Stones concert in Munich, and the duo (Jones was also something of a clotheshorse) began dressing in finds from trips to Morocco. Although she left Jones for Richards in 1967, Pallenberg's style continued to develop. Her boho look no doubt influenced Richards's now-trademark distressed rock-'n'-roll vibe.

Part of Pallenberg's notoriety comes from being in the right place at the right time – or certainly times that are now part of rock-'n'-roll's documented narrative. She was by Richards's side for court appearances following drug busts and appeared in *Performance*, the 1970 film that also starred Mick Jagger (it is rumoured that the two had an affair onset). It could all happily be on loop for fashion fans with a boho predilection. Captured in fringing, fur coats and other finery, the film shows Pallenberg at the height of her powers.

If Pallenberg's appeal was partly down to charisma, this image – a still from 1970's *Performance* – goes some way to capturing her thrown-together style. The satin blouse, worn with a belt and a necklace over the top, may looks nonchalant, but it is the kind of thing you could study for hours and still not successfully imitate.

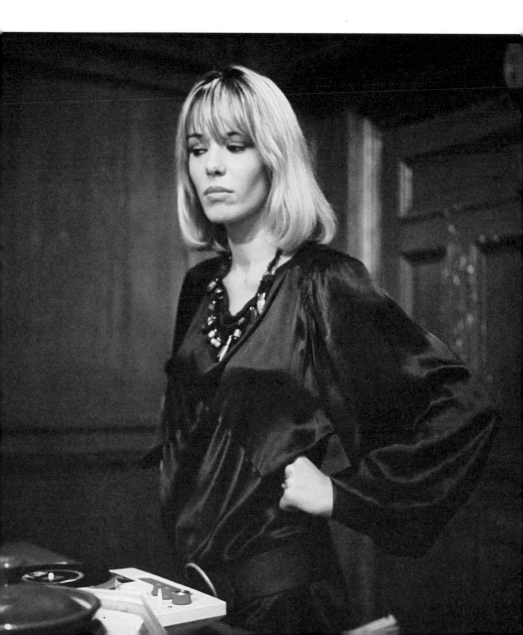

PATTI SMITH 1971

With Patti Smith (1946–), it is the simple things that matter most: a white shirt, a blazer slung over the shoulder, jeans, braces (suspenders) and wild hair. This was the outfit she wore when she was photographed by her friend and sometime lover Robert Mapplethorpe for the cover of her debut album *Horses* in 1975. If the spare, poetic music Smith produced has ensured the album has become a classic in the 40 years since then, so, too, has her style. Smith is now the last word in chic, easy androgyny. Ann Demeulemeester was particularly influenced by her: seeing the cover of *Horses* as a 16-year-old was instrumental in the designer developing that pared-back rock aesthetic that Smith loves. The two women went on to become good friends and collaborators.

Raised in New Jersey, Smith moved to Manhattan and into the Chelsea Hotel with Mapplethorpe as a young woman in the late 1960s. She was soon entrenched in the world of bohemia, and her look was as important as her surroundings. It was a photograph of Edie Sedgwick in *Vogue* in 1965 that first inspired her. 'It represented everything to me,' she said, 'radiating intelligence, speed, being connected with the moment.'

This will be familiar to readers of Smith's autobiography, *Just Kids*, published in 2010 and due to be made into a television series. It will no doubt see another generation adopt the singer's uniform of simple pieces imbued with a punk attitude. And that white shirt? As Smith recounts in *Just Kids*, it was picked up from a Salvation Army store. 'I had no sense of how it would look, just that it should be true,' she wrote. And so it was.

Smith in her natural environment, the Chelsea Hotel, in 1971. The singer lived in the hotel, which was also home to other artists and writers, including William Burroughs, throughout the 1970s. The creative atmosphere shows in her tousled hair, black T-shirt and simple jewellery. Perfect for watching Manhattan go by.

The now-classic cover of 1975's *Horses*. Smith was photographed by her friend Robert Mapplethorpe, in a pose she has described as 'a mix of Baudelaire and Sinatra'. A stark contrast to a lot of media images of female singers at the time, it has gone on to be a reference point for fashion and feminism alike.

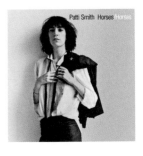

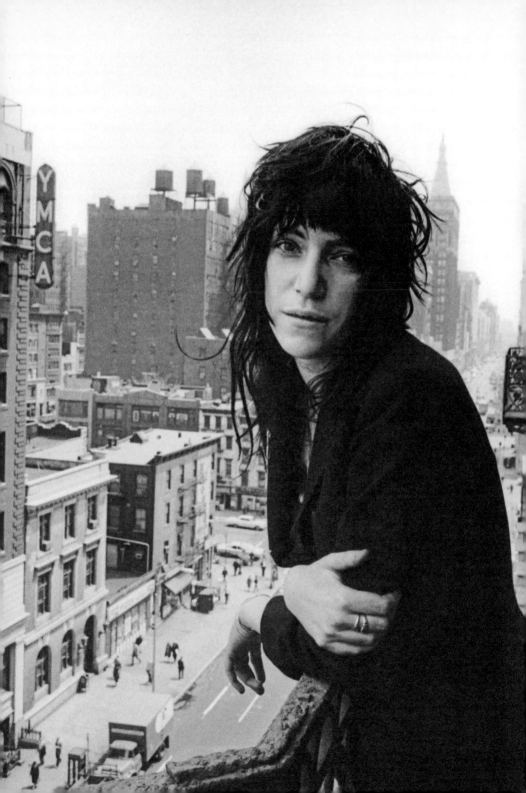

JACKIE KENNEDY ONASSIS 1971

While the pink Chanel-style suit and pillbox hat she wore on that fateful day in Dallas in 1963 will always be infamous, Jackie Kennedy (1929–84) – later Onassis – had such style clout that her influence extends well beyond the split second that changed American history for ever.

Only 31 when she became First Lady, Kennedy's relative youth and interest in fashion saw the eyes of the world quickly focus on her as an American style icon. During her three years in the White House, she became known for her smart skirt suits and discreetly glamorous gowns when on duty, and the preppy shirts, boat-neck jumpers and sneakers she wore when off. Her triumphs may have been down to her love of fashion and shopping. In her first year as First Lady, she reportedly spent $45,446 (around £30,000) more on her wardrobe than the $100,000 (around £70,000) that her husband earned as President. Such a move could be seen as frivolous, but perhaps Kennedy knew she needed to look the part. She hired Hollywood designer Oleg Cassini, and together they honed a look that was simple, respectable and always chic. Crucially for the women who watched her, it was also easy to imitate. Jackie Kennedy style took over Middle America.

Her fashion prowess continued after fate took her away from the White House. In 1968 she married shipping magnate Aristotle Onassis, and the 1970s is every fashion insider's favourite Jackie era. Snapped on the streets of New York in skinny-ribbed sweaters, flares, flats and those now signature round, wide sunglasses, carrying a discreet but expensive Hermès handbag, she looks relaxed, cool and – of course – chic.

This is 1970s Jackie at her most iconic. Strolling the Upper East Side streets of New York in a simple sweater and jeans, she is meant to be incognito. But those sunglasses and that blown-out hair – not to mention the incoming paparazzo – make her anything but.

The Kennedys were the original presidential power couple, and they look the part at an inauguration event for 'Jack' Kennedy's presidency in 1961. Jackie's clean-lined femininity (here showcased in a dress designed by Oleg Cassini) soon became the template for American women, although they may have had to forgo the piled-on jewels seen here.

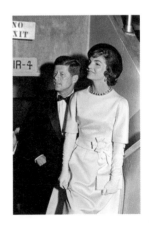

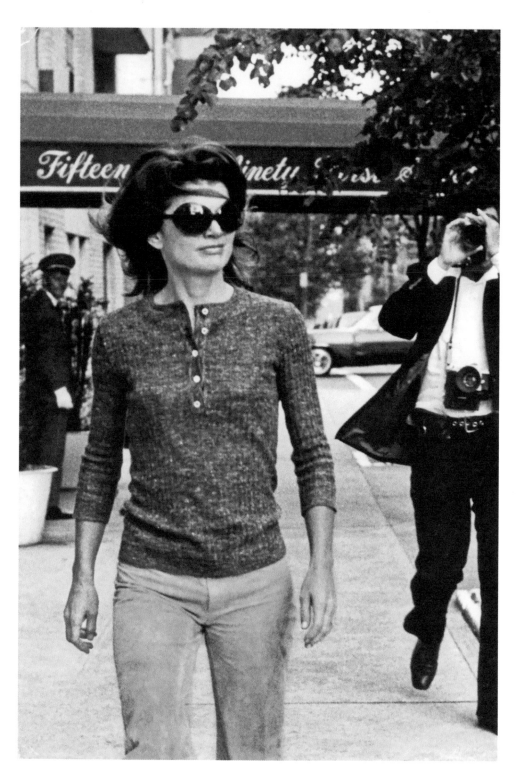

PAM GRIER

In the trailer for the 1974 film *Foxy Brown*, the title character is introduced thus: 'When Foxy Browns comes to town, all the brothers gather round…' And well they might. For a certain period in the mid-1970s, Pam Grier (1949–), who played Brown, was the pin-up of blaxploitation films, which invariably featured strong, sexy black women who took on the male gangsters that were usually part of the plot, and won. If Richard Roundtree's famous character John Shaft, in his black polo-neck and leather coat, was the hero, Grier's Brown was the heroine. Blaxploitation's mix of glamour and street smarts was one that she wore well.

Grier's look in the 1970s comprised flares, big collars, shirts tied at the midriff, a mini-Afro and gold hoop earrings. It is one that continues to have traction, notably on Beyoncé Knowles in 2002's *Austin Powers in Goldmember*, in which she played Foxxy Cleopatra, a direct homage to Grier's Brown.

Grier's second coming was more than 20 years after Foxy, when the actor reprised her character's surname in Quentin Tarantino's 1997 *Jackie Brown*. While the Afro was gone, Grier's cool demeanour, sharp cheekbones and those hoop earrings were introduced to another generation, who also, no doubt, noted her chic air-stewardess outfit. With blaxploitation style a reference point for the clothes in Lee Daniels's 2015 hit television series *Empire*, Grier is now influencing yet another. As an original action heroine, she has now represented cool, tough women who stand up for themselves for more than five decades.

Grier in her standard blaxploitation outfit in 1972. It might not be the obvious choice for an action hero but it served her well in films throughout the 1970s – as did an ability to take down any baddies foolhardy enough to cross her path.

As the poster for 1974's *Foxy Brown* suggests, Grier is not a woman to be messed with. An icon of a movement, she's not only the title character here but also the poster girl to sell this classic movie. With that mane of hair and strategically positioned gown, it is easy to see why.

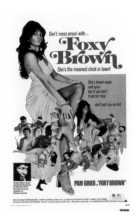

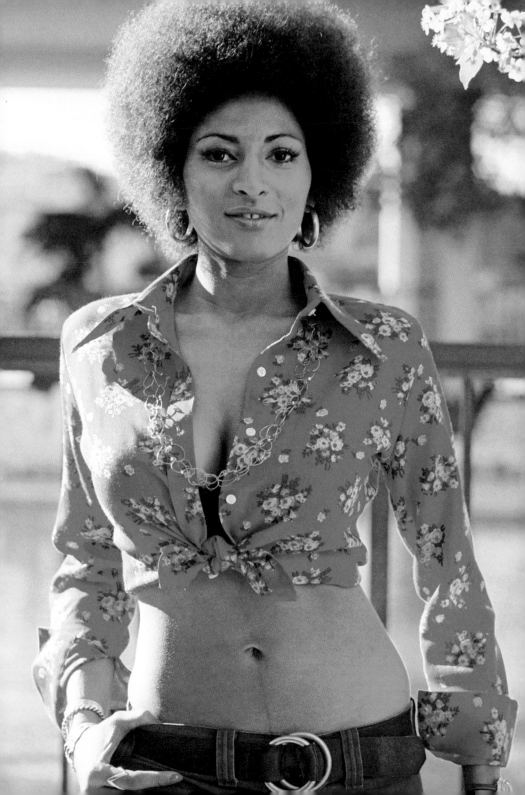

JANE BIRKIN

Jane Birkin (1946–) could be described as the most French Englishwoman the fashion world has ever known. She is certainly the only one who has a bag made by Hermès – that most French of luxury fashion houses – named in her honour.

Birkin's story goes back to the mid-1960s, when she appeared in *Blow-Up* (1966), the classic film of the era detailing the London fashion world. An aspiring actor, she then moved to France and appeared in a film called *Slogan* (1969), also starring Serge Gainsbourg. While the film is now largely forgotten, the relationship it sparked off certainly is not. Gainsbourg and Birkin became the golden couple of Paris, with Birkin's orgasmic vocals on Gainsbourg's 1969 hit 'Je t'aime … moi non plus' typifying their star-crossed dynamic – Birkin's wide-eyed innocence to Gainsbourg's tousled experience.

Birkin was photographed endlessly in this period, often by her brother Andrew, and these intimate family album shots are testament to her earthy, laid-back style. She was a mother to two young children by the early 1970s, and the Birkin look is a mix of the practical and chic, full of the kind of off-duty effortlessness all women want to replicate. High-waisted flared jeans, white shirts and ballet flats were staples, along with the by now trademark wicker basket that Birkin carried. After dark and out with Gainsbourg, she had an appropriately thrown-together approach to glamour – all fringed dresses and miniskirts, perfect for dancing.

And then there is that 'Birkin' bag. The story goes that the actor gave Hermès permission to use her name to create a bag with pockets after she shared a flight, in 1981, with the then head of the house, Jean-Louis Dumas. It is now one of the biggest status symbols in fashion, with Victoria Beckham reportedly in possession of more than 100. There is little doubt that Birkin's name – a byword for easy chic – contributed to its success.

Birkin has always been about a simple but effective – perfectly chic – formula. Here, outside her London home, she is at the height of her powers. Note the now familiar Birkin-isms: basket, white T-shirt, tousled fringe, beat-up jeans and eyes to fall into.

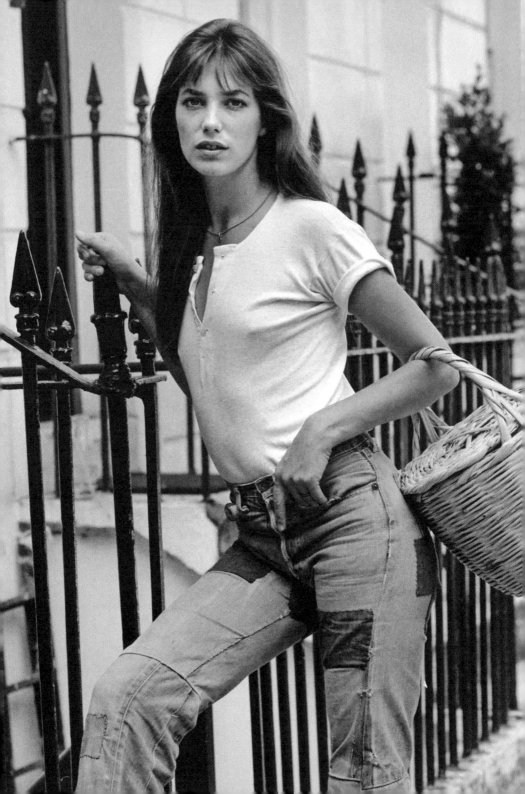

BIANCA JAGGER 1974

Bianca Jagger's connection to fashion can be traced back to *that* moment – when she was photographed on a white horse at Studio 54 in New York in 1977. She has since clarified that she did not ride said horse into the nightclub like Lady Godiva, but no matter. The image of Jagger on the eve of her thirty-second birthday, wearing a red off-the-shoulder Halston gown and blown-out hair, has gone on to enter the photo album of the 1970s, the definitive decade of hedonism and hedonistic style.

An earlier event had started the process of Bianca Jagger (1945–) becoming a face of a decade: her wedding day in 1971. She was dressed by Yves Saint Laurent, and folklore has since given the impression that she wore a white trouser suit whereas it was, in fact, a long skirt and jacket. The point remains, however: Jagger was never afraid to experiment, but she always remained chic. It is a lesson party girls could learn from, whatever the era.

Jagger's fashion prowess goes beyond these two particular highlights, of course. The Nicaraguan-born activist and her then husband Mick Jagger were a key part of the disco scene, one that saw her become friends with Halston and Andy Warhol, and party at Studio 54 in New York and Le Sept in Paris. Images of these evenings have been pored over in the nearly 40 years since, with designers ranging from Marc Jacobs to Balmain's Olivier Rousteing enthralled. Jagger, with her cheekbones, mane of black hair and enviable wardrobe, is now a mood-board regular.

Looking at Bianca Jagger is a lesson in after-dark style. She went out throughout the 1970s and looked flawless whatever the event. This gathered gold goddess gown is typical, as are the side-swept bob of luxuriant hair and the make-up to emphasizing those unmistakable cheekbones.

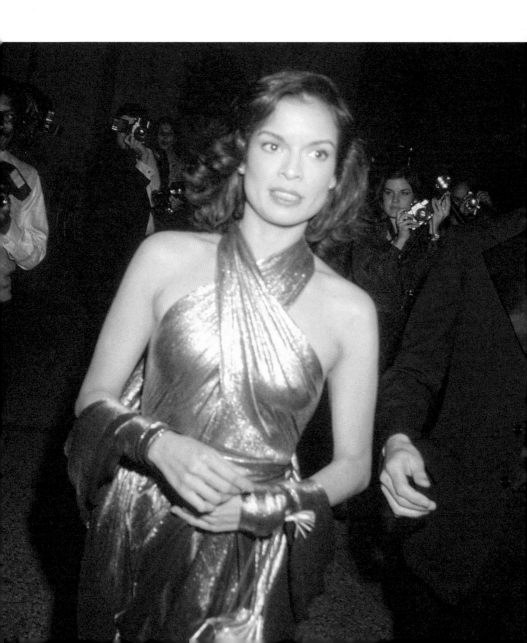

'LITTLE EDIE'

Marc Jacobs can always been counted on to know his cult figures. This was certainly the case when he based his Spring/Summer 2008 collection on the 1975 documentary *Grey Gardens*, and its subjects, mother and daughter 'Big Edie' and 'Little Edie' Bouvier Beale. He was joined by John Galliano the same season. The British designer produced a collection that included headscarves and oddly placed brooches, in a way that would be familiar to fans of the film – among whom number Kylie Minogue and fashion photographer Steven Meisel.

Relatives of Jackie Kennedy Onassis, the Bouvier Beales lived in Grey Gardens, a dilapidated mansion in the Hamptons, with 52 cats. In the mid-1970s they were filmed by the brothers Albert and David Maysles – who also made the Rolling Stones documentary *Gimme Shelter* (1970), and the result is a portrait of faded privilege and eccentricity. The daughter, Edith Bouvier Beale (1917–2002), who had worked as a model and actor in her youth, emerged as the most fashion-friendly of the two, with her headscarves (prompted by her hair falling out in her twenties), brooches and unusual styling tips. She wore tablecloths as skirts and back-to-front sweaters – sometimes Jackie's cast-offs – typically calling her outfits 'revolutionary costumes'.

This anarchic spirit was brought to the masses in 2009, when Drew Barrymore played 'Little Edie' in an HBO biopic about the Bouvier Beales, also called *Grey Gardens*. Fashion eccentric played by Hollywood royalty? Little Edie's place in style's canon of muses was assured.

The disapproving scowl and the hand on the hip say it all here – 'Little Edie' is not to be messed with. Fans will note the fur coat, headscarf and lipstick. Their cult heroine is an icon of eccentric, outsider glamour – just like her house, Grey Gardens, seen here in the background.

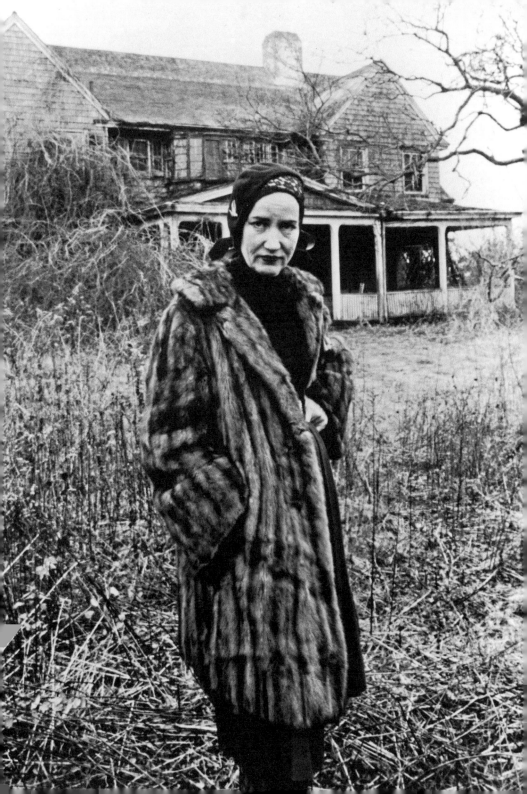

JOAN DIDION

Not many 80-year-olds feature in the advertising campaigns of the world's most influential fashion brands, but Joan Didion (1934–) is not your average octogenarian. Photographed by Juergen Teller, the writer accordingly starred in Céline's Spring/Summer 2015 campaign, wearing a ribbed black polo-neck, a long necklace with a large gold pendant and enormous black sunglasses. Predictably, it was the kind of image that sets the Internet on fire. Modern fashion likes nothing more than paying homage to a cult figure.

Didion's appeal for Céline designer Phoebe Philo lies not only in her fine – and prolific – career writing essays, journalism and novels, but also in her natural affinity with clothes. This is something that Philo – and the women that buy her clothes – would appreciate. In accordance with her prose, Didion is never fussy. The native Californian is much more likely to be found in a sloppy sweater and very little make-up than a dressed-up gown. Seven years working at *Vogue* at the start of her career may have had their effect but, as with everything in Didion's world, her style is fuelled by a kind of no-frills simplicity.

Following the Céline ad, American website Gawker described the writer as 'an ever more popular lifestyle brand' while American *Vogue* dubbed her the 'immortal intellectual-and-otherwise dream girl'. Her distinctly minimal packing list of items to bring on a trip, published in 1979's *The White Album*, has appeared on many fashion and beauty websites, including *Into the Gloss*. Post-Céline, dropping Didion's name into conversation implies you are well read in both literature and style.

Stark, no-nonsense and supremely confident, Didion in her apartment in 1977 is an image of a woman in control. The simple black top and skirt are effortless and easy. The no-make-up grooming and freshly washed hair add to the feeling of naturalism.

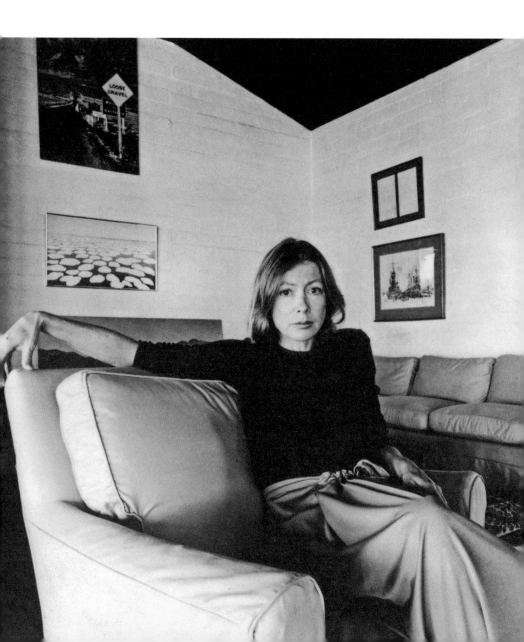

DEBBIE HARRY

As the face – and namesake – of punk-pop band Blondie, Debbie Harry (1945–) featured on posters covering the walls of teenager's bedrooms throughout the late 1970s. With her peroxide hair, cheekbones designed for the liberal application of blusher and a lip-glossed pout, she summed up rock-'n'-roll glamour in the era.

Harry's look came from the scene she was a part of – New York clubs such as CBGB and The Roxy, as well as uptown disco destinations including Studio 54. Mixing the do-it-yourself aesthetic of punk with the scruffy, biker-influenced feel of rock 'n' roll and the gloss and shine of disco, she was an amalgam of a city's youth culture. She brought it all into mainstream America with Blondie. After 'Heart of Glass' became a global hit in 1979, the band and Harry were household names.

At the height of Blondie's fame, Harry's dress sense became something to note, partly due to some of her more unusual choices of clothing. This included a dress made from a black plastic rubbis bag that she wore in the video for 'Atomic' in 1980. As a woman in a band of men, these clothes allowed her to stand out, provide the style and hold her own as a strong frontwoman.

Part of Harry's fashion prowess came from her collaborations with designers, particularly Stephen Sprouse, with whom she worked from 1975. Sprouse, who was also entrenched in that underground scene, was responsible for Harry's asymmetric dresses, and he encouraged her playfulness with colour, including a signature hot pink. Harry is still performing and still a key reference for young women discovering how to be a girl in a band and look the part. The number of peroxided heads dotting city streets is testament to that.

Harry's stage wear often used colour and texture to pack a punch. If, sometimes, that involved more typically punk methods such as black bin bags, this outfit, for a show at the New York Palladium in 1978 is her fashion-friendly guise, with red thigh-high boots and a matching red tunic. The shag of peroxide hair and black kohl are always in attendance.

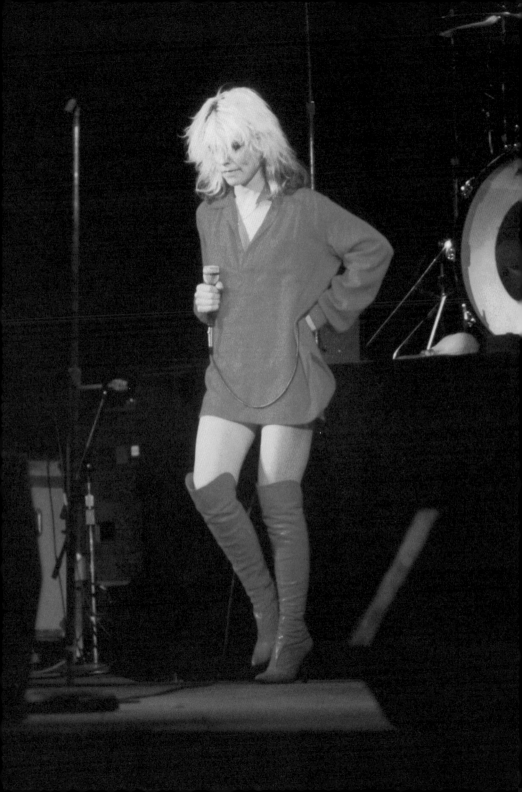

ANNIE LENNOX

Annie Lennox's bright-auburn buzz cut stuck out in the 1980s – a decade known for hair that might have come with the motto 'the bigger, the better'. It stars in the video for the Eurythmics' 1983 hit 'Sweet Dreams (Are Made of This)', combined with other Lennox trademarks – sculptural make-up and a man's suit and tie. Speaking to *Interview* magazine in 2014, Lennox reflected that she 'wanted to create something that was quite edgy and belonged to me...It was saying that appearance is just temporary, and I want to be as strong as a man.'

Lennox (1954–) has since pushed at the gender boundaries of fashion in pop music for four decades, but it is still the 1980s with which she is most associated. The singer, originally from Scotland, formed Eurythmics with Dave Stewart in 1980, and went on to dominate the pop charts of the decade – 'Sweet Dreams' went to number two in the UK Singles Chart. Lennox's look was part of their success. Other memorable moments include the Zorro-like mask she sported on the album cover of *Touch* (1983), and the tartan suits she wore for live shows. After going solo in 1990, the videos for 'Why?' (1992) and 'Walking on Broken Glass' (1992) saw her adopt more archly feminine clothes including ball gowns and feather boas. The crop always added edge.

While Lennox now is more known for her philanthropy than pop stardom, she has passed on her fashion flair to the next generation. Her daughter Tali is a successful model. And that buzz cut is cool once again: models Ruth Bell and Kris Gottschalk, who both wear their hair shorn, are Lennox's style descendants.

This is Lennox pre-Eurythmics, in 1979, but the style signs are all there: bright cropped hair, statement make-up and androgynous tailoring. She may not have known it then, but this look was set to inspire and certainly influence generations to come.

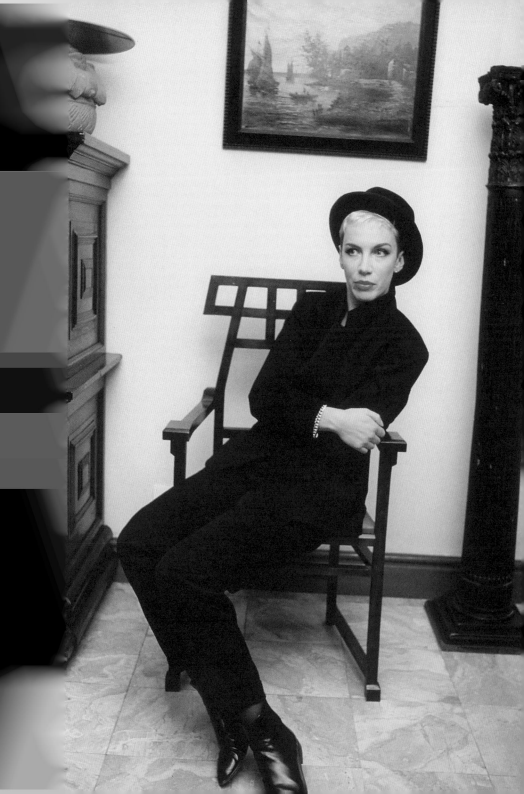

DIANA VREELAND

Diana Vreeland's pithy sayings are as much a part of her mythology as her 30-odd years editing first *Harper's Bazaar* and then American *Vogue*. When discussing what she herself wore, one line in particular stands out: 'Style – all who have it share one thing: originality.' Vreeland certainly practised what she preached. In her look as well as her work, she was one of a kind.

Diana Vreeland (1903–89) was born in Paris and moved to New York as a young child. She began working in fashion as a lingerie buyer with clients including Wallis Simpson. Landing a job as a columnist at *Harper's Bazaar* in 1936 started Vreeland's ascent to the top of fashion. She wrote a column entitled 'Why Don't You…?', suggesting fun ideas to readers, including buying bright yellow leashes for dogs, or having your bed made in China. She might have asked herself the same question before she commissioned the interior designer Billy Baldwin to decorate the rooms of her Park Avenue apartment in bright chintz red.

This anything-goes spirit fuelled what she wore, although, in reality, Vreeland – a busy woman, no doubt – subtly stuck to a formula. If her earlier experimentation shows print and colour, her time as fashion matriarch – a role she owned from her appointment at *Vogue* in 1962 – saw her dressing in black blouses or white shirts and grey slacks. But, Vreeland being Vreeland, these pieces served as a backdrop to outlandish jewellery and accessories, always with an air of exoticism, sometimes worn with a turban and certainly with red lipstick.

Lisa Immordino Vreeland's 2011 documentary about her grandmother-in-law was entitled *The Eye Has to Travel* after one of Vreeland's aphorisms. Vreeland's eclecticism and thirst for the new were her triumphs. And it was evident just by looking at her.

The pose says it all: Vreeland is in the know. She is pictured in the late 1970s with all her trademark pieces: vibrant jewellery, draped scarf, white shirt and grey slacks. The playful expression and swept-back black hair only add to a satisfying image of a woman who shaped fashion into what we recognize today.

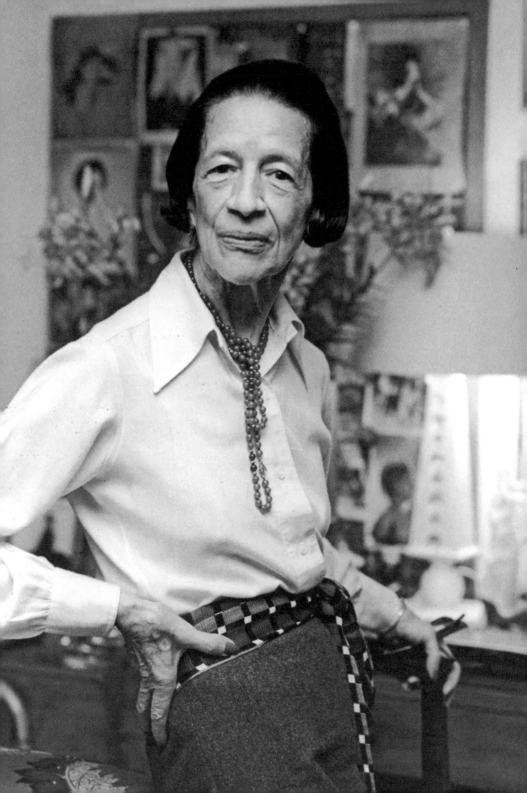

GRACE JONES

In her 2015 autobiography, *I'll Never Write My Memoirs*, Grace Jones (1948–) – never known for keeping her opinions to herself – accuses modern pop stars including Rihanna, Nicki Minaj and Miley Cyrus of imitating her style. 'They do my thing, a little their way, but not much,' she writes. While this could sound like sour grapes, she may have a point. Jones has been so influential that pop stars now would be hard pushed not to reference her in some way.

A Jamaican-born model who walked for designers including Yves Saint Laurent, Jones first started to make waves on the disco scene in the late 1970s, performing in outlandish outfits. It was at one of these performances – wearing a tutu – that she met Jean-Paul Goude, who was to become her partner and her collaborator on her striking image.

Her fame began with her fourth album, *Warm Leatherette*, which was released in 1980. With it came a new, more electronic sound and the look to match. Jones appears on the cover, which was designed by Goude, with a flat top and glossed lips, wearing Issey Miyake shoulder pads. This androgynous mix was one she made her own over the next decade, with her body taking centre stage. Her 1981 album, *Nightclubbing*, saw her topless in a man's suit, while 1985's *Island Life* made her superhuman, holding a yoga pose while wearing only a strapless bikini top, thong and a boxer's limb support (it has since been revealed that this image was constructed by Goude using several photographs of Jones). The following year, her body was painted by artist Keith Haring for her performance in the comedy horror film *Vamp*.

These are just some of the looks that Jones has given the pop world. Her influence may irk her but, as one of the first artists to put image on a par with material, it is irresistible.

Jones was as much about using images to create a persona as she was about conventional photographs. This promotional poster for 1981's *Nightclubbing* album is a case in point. On a yellow background, the broad-shouldered, gloss-lipped, cigarette-smoking Jones is in relief, and is quite extraordinary.

GRACE JONES/NIGHTCLUBBING

NOUVEL ALBUM

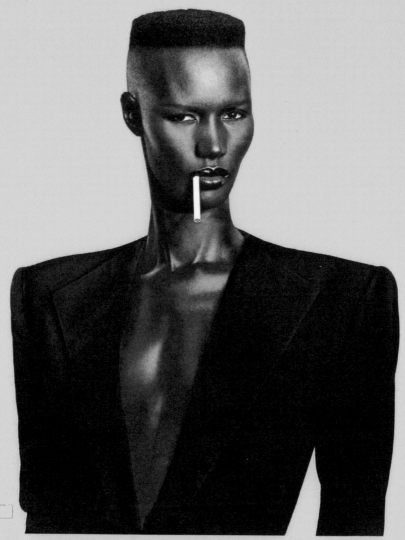

ISLAND

"I´VE SEEN THAT FACE BEFORE"
(LIBERTANGO)

c'est une publication **phonogram**

TINA CHOW

Cited as a muse of photographers from Helmut Newton to Steven Meisel, and immortalized by her friend Andy Warhol in one of his screen prints in 1985, Tina Chow (1950–92) was at the nucleus of cool during the 1980s. The daughter of a Japanese mother and American father, she was one of the first Asian women to make it as a model in the West. She worked for designers ranging from Karl Lagerfeld to Yves Saint Laurent, and was the face of Japanese make-up brand Shiseido at the age of 16.

Born Bettina Lutz, she became Tina Chow after her marriage to restaurateur Michael Chow in 1973, whom she had met through Zandra Rhodes. As one half of an It couple, she quickly became the face of the operation. Known for wearing sharp tailoring, graphic shapes and long, slinky dresses, Chow was a keen collector of clothes and would mix haute couture with flea-market finds. Everything was topped off with her signature slicked-back short hair, jewellery – sometimes of her own design – and slash of red lipstick. The insider accolades came from the top table: Lagerfeld credited Chow with starting minimalism.

One of the first heterosexual women in the public eye to be diagnosed with AIDS (she died from it in 1992 at the age of 41), Chow began to concentrate on designing jewellery, furniture and sculpture towards the end of her life, moving from the frenetic world of Manhattan to California. Her cult appeal continues. A sale of her Kyoto bracelets in 2010 had fashion's interest piqued, and designers including Marc Jacobs have been inspired by her. And – perhaps this is the ultimate posthumous acclaim – Kate Moss has namechecked Chow as her style icon.

Pictured in vintage Fortuny accessorized with one of her own bracelets, Chow is elegant, enigmatic and starkly modern. As such, she quickly became a style icon for the 1980s insider elite.

Chow had friends in all the right places. In this 1982 photograph of her by illustrator Tony Viramontes, she is wearing Chanel and the bold jewellery, red lipstick and cropped hair that she became well known for, but it is the soft power of her profile that makes the image.

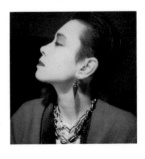

MADONNA

As a woman at the forefront of pop music for four decades, it goes without saying that Madonna (1958–) is also a style icon. Judging her only on her ability to shapeshift, she would get top marks.

Madonna – or Madonna Louise Ciccone, as she was christened – first exploded on to the scene in 1980s New York, a decade that *i-D* magazine claimed 'belonged to her'. Moving from the downtown club look of bangles, headscarves and denim for early singles such as 1983's 'Holiday' and the film *Desperately Seeking Susan* (1985), she was a 1950s film star for 'True Blue' in 1986, and cartoonish for 'Who's That Girl?' the following year. With her videos on heavy rotation on MTV, teenagers everywhere were soon decked out in Ciccone-approved bangles and boots.

The 1990s saw Madonna cross over from street fashion to designer – she worked with Dolce & Gabbana, Versace and Jean Paul Gaultier, with the last designing her famous conical bra for the 1990 Blonde Ambition tour. The costumes were later described as 'power and sensuality combined', and these two elements are the key to Madonna's style: it is always sexy, but always in control. Her trope of underwear-as-outerwear is a fine example.

Madonna continues to play with what she wears and has starred in campaigns for Dolce & Gabbana and Versace. She regularly works with Arianne Phillips, the stylist and Oscar-nominated costume designer. Her 2015–16 tour Rebel Heart featured costumes by a clutch of interesting designers – Gucci's Alessandro Michele, Alexander Wang, Fausto Puglisi and Jeremy Scott for Moschino. Quite right, too, for the Queen of Pop.

The Madonna to launch a million imitators, seen here on tour in 1984. This mid-1980s look – piled-on accessories, exposed midriff, black layers – inspired the singer's growing fanbase to dress exactly like her. It was an impulse that they acted on for many decades.

Madonna in Jean Paul Gaultier on the Blonde Ambition tour in 1990. Her need to push boundaries increasingly extended into what she wore. The corsets and fishnets might seem standard now but then it added to the singer's happily scandalous reputation.

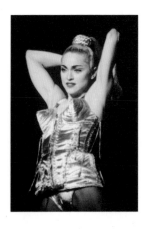

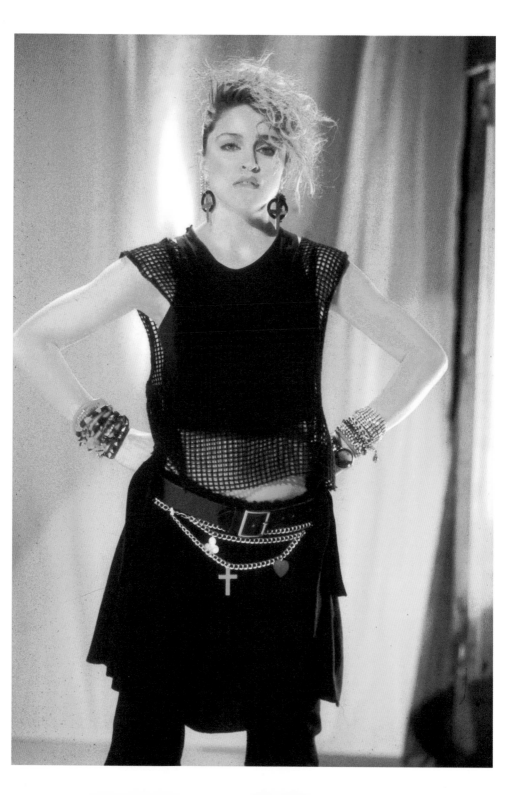

NENEH CHERRY

In *i-D* magazine's *Encyclopaedia of the 1980s*, published in 1990, Neneh Cherry (1964–) is described as 'smart, sexy and with all the right connections…the face perfectly suited to the nineties'. In fact, the 26-year-old was already making her mark. With her debut album, *Raw Like Sushi*, released in 1989, Cherry, a Swedish singer of mixed-race descent living in London, became a symbol of diverse and creative style in the UK capital.

Cherry's look came from the same place as *i-D* – the clubbing scene; she even helped staple issues of the magazine together in the early 1980s. It was at this time that the singer met Judy Blame, the stylist and jewellery designer who still works with her today. Together, they would source clothes from up-and-coming designers and mix them with things found at street level. In 2014 Cherry credited Blame with her ability to 'create fashion that's anti-fashion'. Ray Petri, a stylist for *The Face* and creator of the so-called Buffalo look, added a tougher element.

Two moments are key: first, the cover of *Raw Like Sushi*, shot by Jean-Baptiste Mondino, featuring Cherry in chunky gold jewellery and a black slip, wearing an expression that prompted Petri to describe her as a 'female Mohammed Ali'; and, second, an appearance on the UK music chart television programme *Top of the Pops* a year earlier, where a seven-months-pregnant Cherry performed in bodycon separates, bomber jacket and trainers. This is typical of Cherry: she shuns glamour and artifice in favour of the eclecticism, spontaneity and practicality of the street. It is something that artists now – from Rihanna to Lily Allen – can only try to replicate.

A bomber jacket, trainers, hoop earrings and just the merest hint of a pregnancy bump, this is Neneh Cherry's style nailed: real, practical, fun and ready to go. She swiftly became a heroine to a generation when she wore a similar outfit – bump visible – on *Top of the Pops* in 1988, a year ahead of her classic album *Raw Like Sushi*.

COURTNEY LOVE

As one half of grunge's power couple, Courtney Love (1964–) would have been bemused to see a stained cardigan once belonging to her late husband Kurt Cobain fetch nearly £100,000 at an auction in 2015. But, should she happen to come across one of the ripped, torn and destroyed slip dresses she once wore, there is little doubt that it could raise a similar sum.

Love came to prominence in the 1990s, as the lead singer of Hole. The five-piece had the clothes to match the era's downbeat sound – which came to be known as grunge – and Love, who married Cobain in 1992, was its golden girl. Her exaggerated make-up, bunches of peroxide hair with grown-out roots and raggedy thrift dresses became part of what was known as 'kinderwhore' – part cute and girly, part seductive, but with the *grrr* of riot grrrl. As grunge grew in popularity, boys dressed in Cobain's cardigans and girls wore Love's slip dresses, ripped tights and boots.

While Cobain's fashion influence has been preserved in aspic since his death in 1994, Love's looks have evolved. The year 1996 saw her star in *The People vs. Larry Flynt*, with costumes by Arianne Phillips taking her through decades from the 1960s to the 1980s. She went on to adopt high glamour in campaigns for Versace in 1998, while recent campaigns for Saint Laurent and front-row spots at Givenchy suggest her power still holds. Peroxide-blonde tresses aside, 1990s Love and Love today are two very different – but equally enticing – fashion people. The singer is a consummate style chameleon.

The detritus of this 1995 image is just the right environment for Love – cigarettes, an unmade bed, copies of *Vogue* and a pile of books all feed into her look. In fact, such disparate elements make sense when looking at her, in a babydoll dress, ripped tights and peroxide barnet. A mess, sure, but a stylish one.

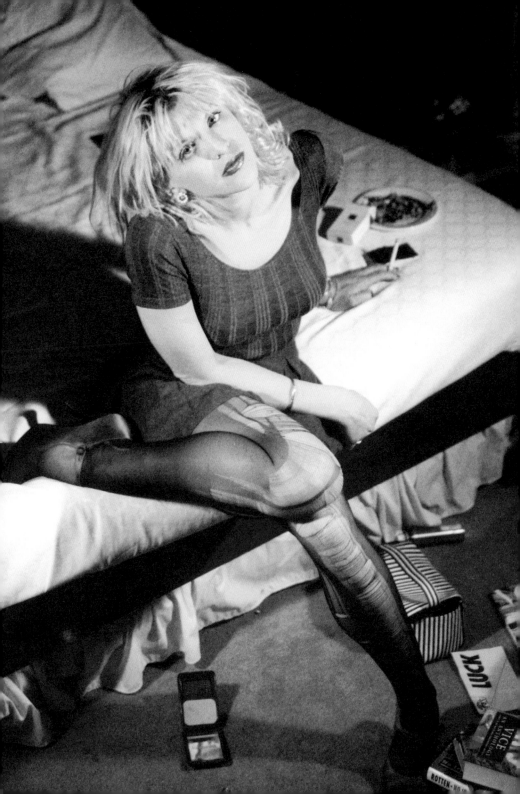

PRINCESS DIANA

In Peter York and Ann Barr's 1982 classic *The Official Sloane Ranger Handbook*, dedicated to the well-heeled London subculture, the Princess of Wales (1961–97) was dubbed 'the 1980s Super Sloane'. As such, the former Lady Diana Spencer is credited with bringing Sloane Ranger style – velvet hairbands, ruffled white shirts, loafers – to the masses, following her engagement to Prince Charles in February 1981.

Given her title 'The People's Princess', Diana's influence on the clothes worn by the general public extends beyond one look. The ivory silk wedding dress she wore to marry Prince Charles in July 1981 was designed by David and Elizabeth Emanuel. Period appropriate in its maximalism, with its 7.6m (25ft) train and puff sleeves, the design dominated bridal trends for the decade.

Diana consistently supported British designers. Along with Emanuel, she wore Bruce Oldfield and Catherine Walker in the 1980s. A collection of dresses from this period was sold at auction in 2013, including a midnight-blue gown by Victor Edelstein that Diana wore to dance with John Travolta at the White House in 1985. It alone raised £240,000.

The 1990s saw Diana fully embraced by fashion's inner circle. She was photographed for *Vogue* by Patrick Demarchelier in 1991, appearing on the cover of the magazine in a simple black polo-neck. While daytime engagements saw her chic in khakis and white shirts, she sometimes wore the more dressed-up designs of her friend Gianni Versace in the evening.

In 1992 she separated from Prince Charles. Christina Stambolian's off-the-shoulder black bodycon design – since christened 'the revenge dress' – was what she chose to wear to an event the night after the Prince admitted his infidelity to the media in 1994. In that one move, Diana quietly demonstrated that she knew the power of fashion.

Here is Diana in 1995: slick, sophisticated and, as the huge sapphire in her necklace signifies, always aristocratic. The Princess, in a Catherine Walker dress, manages to circumnavigate the chaos of the awards ceremony around her, making her a beacon of chic.

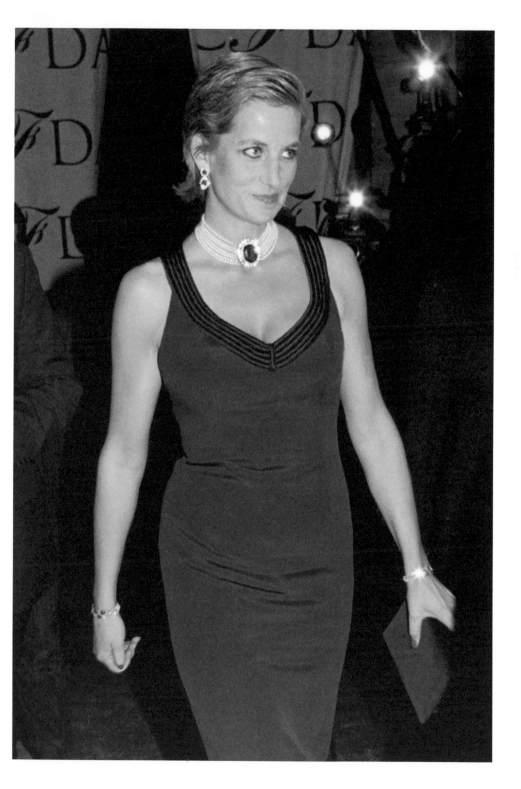

CHLOË SEVIGNY

When you are christened 'the coolest girl in the world' by novelist Jay McInerney in 1994, it might be expected that things would go downhill from then on. Chloë Sevigny (1974–) – said cool girl – would beg to differ. More than 20 years after that pronouncement in *The New Yorker*, the actor, designer, model is as relevant and influential as ever.

Originally from Connecticut, Sevigny entered the pop sphere in New York in the 1990s, as an ex-club kid who went on to star in the video for Sonic Youth's 1992 hit 'Sugar Kane' and Larry Clark's film *Kids* in 1995. Her flair for style always ran in tandem with her acting work, which has ranged from films such as *Boys Don't Cry* (1999) and *Zodiac* (2007) to television series such as *Big Love* (2006–11) and *American Horror Story: Hotel* (2015–16). With an eye for vintage – McInerney wrote 'it's a rare day that she's wearing more than ten dollars worth of clothes' – and the skate style of her then boyfriend Harmony Korine, she became a 1990s darling, the campaign girl of Miu Miu and cover star of *The Face* magazine.

Wisely, the actor has learnt to monetize this influence. She worked with New York brand Opening Ceremony on a range of designs in 2007, and a book published in 2015 collected fashion images of her over 20 years. Today Sevigny wears clothes that cost a lot more than $10 but her attitude to fashion is the same. In an interview with the *Evening Standard* in 2015, she said, 'I hope I am still cool', and she can feel confident that the elusive quality remains. While other stars tend to play it safe on the red carpet, she experiments. Labels Proenza Schouler, J.W. Anderson and Alessandro Michele's Gucci are recent favourites.

There are not many women who can make a beige skirt, navy blouse and sensible boots the coolest thing in the world, but then there's only one Chloë Sevigny. She is seen here photographed in 1996, the year that *Dazed & Confused* magazine put her on the cover, with the words 'Who's That Girl?' We soon found out.

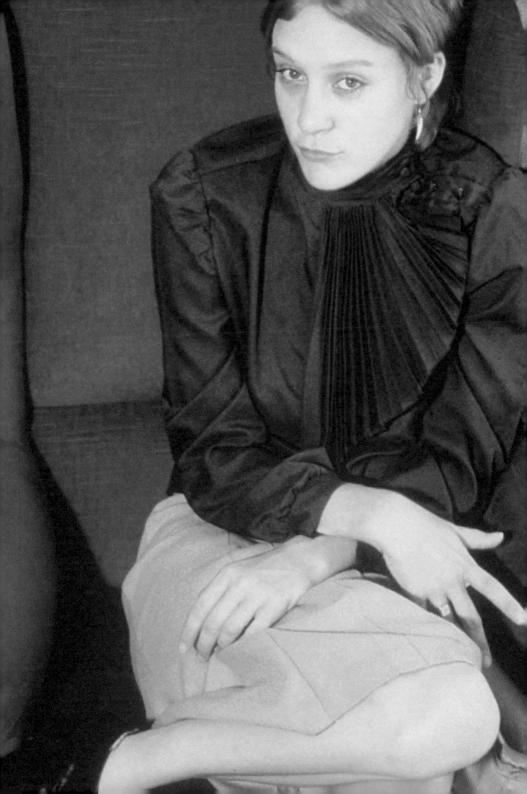

REI KAWAKUBO

Rei Kawakubo (1942–) established her label Comme des Garçons in 1969 and has been in the vanguard of fashion ever since. The designer's empire has grown accordingly, with an annual turnover of around £164 million, and Dover Street Market department stores in Tokyo, London and New York. Unusually for fashion, she has done all of this without courting any cult of personality herself, stating in a rare interview given in 2015 that she does not 'believe in fame'.

Despite never taking a bow after her shows in Paris, and the fact that she has not had a professional portrait taken since 2004, the designer herself is now something of a style reference, beyond what she produces. Kawakubo's look consists of a straight black bob and, if those rare photographs are to be believed, a biker jacket. The clothes she designs continue to search for new meanings and experiences in dress, but Kawakubo's personal style remains consistent.

While she might argue that this uniform is a way to remain inconspicuous, it could be said that it is as much a part of the Comme des Garçons world as the deconstructed designs and department stores. A savvy businesswoman, she has said, 'I design the company so that it's not only clothes…' The black, no-nonsense clothes and millimetre-perfect bob are no accident – they are part of the bigger picture. While Kawakubo may not believe in fame, she does believe in creating a brand.

The most recent official portrait of Rei Kawakubo, taken in 2004, in her signature black and bob. The expression says it all: here is a designer that wants the focus to be on her designs, and not on herself. Unfortunately, fashion does not feel the same. The cult of Rei Kawakubo's style continues apace.

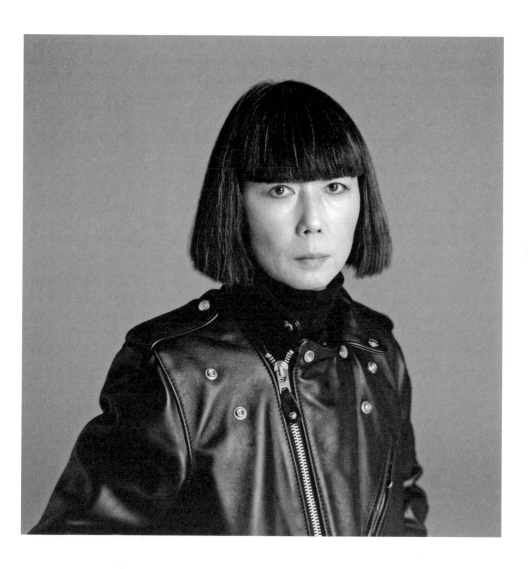

QUEEN ELIZABETH II

At her coronation in 1953, Queen Elizabeth II (1926–) managed to look both regal and – as is understandable for someone aged 26 – youthful. Photographed by Cecil Beaton in Buckingham Palace, her ermine, crown and finery are contrasted with the normal accoutrements of a young woman in the early 1950s – red lipstick, powdered face and set hair.

It is this formula – one of normality mixed with ceremony – that the Queen has stuck to, even as the ingredients have changed. What she wears now, as she enters her nineties, is as familiar and iconic as, say, Homer Simpson's shirt and slacks. The combination of pastel knee-length coat and matching hat, low pumps and capacious Launer handbag is instantly recognizable, and unique to her. The *New York Times* called her outfits 'almost Warholian in their Pop simplicity'.

Sir Hardy Amies was the Queen's official dressmaker for 48 years, from the 1960s onwards, but her clothes are now made by her dressmaker, Angela Kelly. Kelly adapts the clothes to the specifications of a life in the public eye. Fabrics are tested for creasing, weights are sewn into hems so her skirts don't blow around on a windy day, and armholes are cut extra deep to accommodate the royal wave.

While it is widely understood that Britain's longest-serving monarch is indifferent to fashion, the reverse is not true. Designers ranging from Henry Holland to Stella McCartney have expressed a desire to dress the Queen, and Dolce & Gabbana based their Autumn/Winter 2008 collection on her Balmoral uniform of argyle, checks, tweed and headscarves. If her granddaughter-in-law the Duchess of Cambridge has charmed the masses with her big hair and high-street dresses, fashion – always partial to a bit of hierarchy – still prioritizes the Queen.

It takes a lot of wardrobe decisions to be Head of State, especially when faced with less than glamorous environs, such as a rainy and windy Royal Air Force base in 2005. The Queen, resplendent in her trademark pink, with that handbag and those sensible courts, takes it all in her stride.

Less than ten years after her coronation, the Queen had already nailed her colours to the mast. See pastel shades, gloves, a hat and – yes – pearls. This image, taken during a tour of Rome in 1961, is a sign of things to come over the next 60 years.

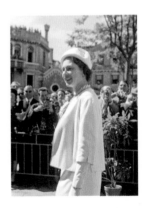

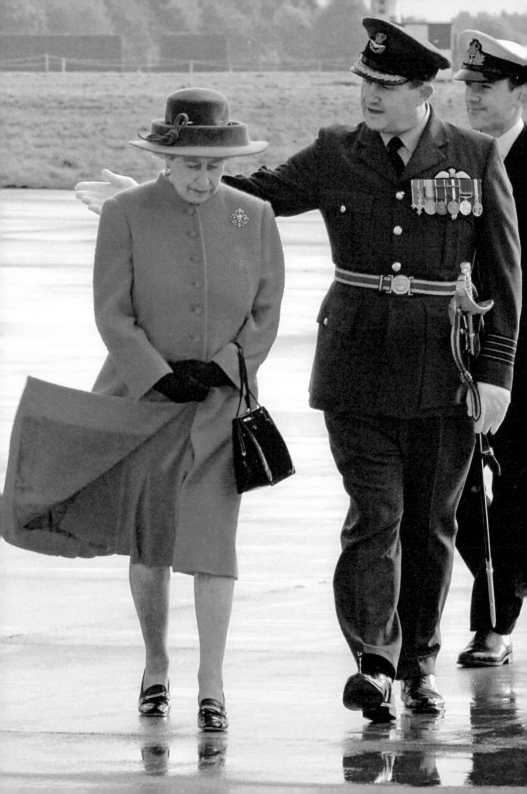

ISABELLA BLOW

2006

Once compared to a piece of public art by the *New Yorker*, Isabella Blow (1958–2007) had a dress sense that was not of the wallflower kind. The fashion editor born into an aristocratic family dating back to the 1300s liked clothes that tended towards the surreal, outlandish and dark. A statement hat, huge fur stole and rubber dress might be a typical outfit, all combined with a flash of bright red lipstick, worn on both mouth and teeth.

Blow began working as an assistant to Anna Wintour, then fashion director at American *Vogue* in New York in the early 1980s. However, it was back in London in the 1990s, at *Tatler*, British *Vogue* and *The Sunday Times,* that she became a fixture on the fashion scene. Blow's taste coincided with a new generation of designers who shared her penchant for drama. In 1992 she bought Alexander McQueen's entire collection after his graduate show at Central Saint Martins. Other favourites included Hussein Chalayan, Julien Macdonald and milliner Philip Treacy. Blow supported these designers during their fledgling years, providing McQueen with the use of her husband's flat in Pimlico as a studio.

As any viewer of Somerset House's 2013 exhibition *Isabella Blow: Fashion Galore!* would have noted, Blow did not keep her clothes in a museum. As the cigarette burns, rips and tears attest, they were very much worn, as standard, whether she was styling a fashion shoot, attending a McQueen show or relaxing at home at Hilles House in Gloucestershire, her husband Detmar's country estate. It was there, in 2007, that Blow committed suicide. She will be remembered in fashion for championing the outer reaches of creativity until the end. Blow was buried in a red-and-gold McQueen dress, and the designer dedicated his Spring/Summer 2008 collection to his recently departed friend.

'More is more' could have been a motto for Isabella Blow. Most people posing in front of a cacophony of colours would have kept their own outfit muted – not Blow. A tartan empire-line gown and a headdress made of feathers are just the thing, whatever activity her day might bring. This image was taken just six months before her death in 2007.

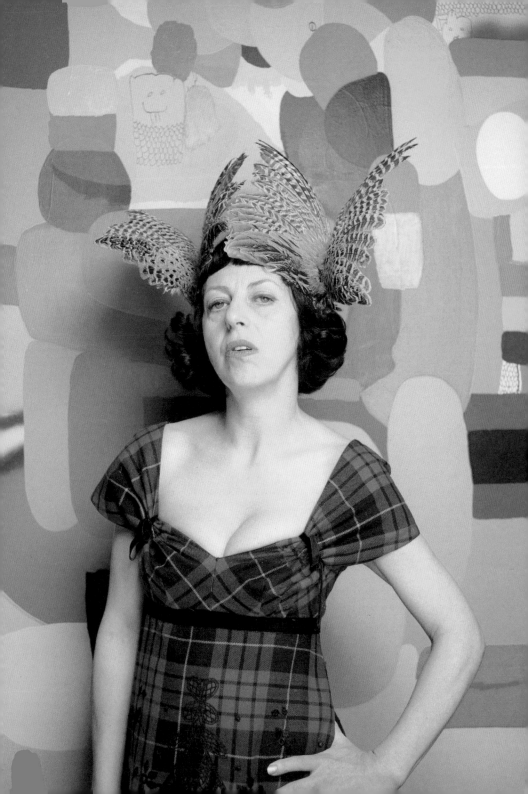

KATE MOSS

2007

Around 1.73m (5ft 8in) tall, with gappy teeth, a lazy eye and bow-legged stance, Kate Moss's statistics do not sound like those of the model – and style icon – that defines our times. But such is the case with the English schoolgirl from Croydon, spotted at an airport in 1988, at the age of 14. Marc Jacobs has called her 'perfectly imperfect', and that sums it up nicely.

Moss's girl-next-door ordinariness chimed with the decade about to hit. The 1990s embraced a downbeat, natural – even grungy – beauty, worlds apart from the glamour and excess that had come before. Kate Moss (1974–) became the decade's figurehead when she met Corinne Day, who photographed the teenager in the early 1990s for *The Face* and *Vogue*, often in scuzzy bedsits or on British beaches. Starring in the advertisement for Calvin Klein's unisex perfume CK One, in 1994 was equally seminal.

Moss is a chameleon who can move from glamorous to stripped-back with ease, whose influence comes, of course, from not only her work with designers and photographers, but also her personal style. Her look has evolved through chiffon slip dresses and Adidas trainers in the 1990s, skinny jeans and ballet pumps in the 2000s, and Hunter wellies and hot pants at Glastonbury. The rest of us regularly follow suit.

Moss's collections for high-street store Topshop have most explicitly demonstrated this influence – the first one in 2007 (for which she was reportedly paid £3 million) had shoppers queuing around the block. A yellow one-shouldered frock and a 1940s tea dress are now classics of high-street collaborations. Part rock chick, part understated chic with a bit of a party-girl edge make up Moss, but it is arguably her attitude that we all want to imitate most. And she shows no sign of losing it.

Here is Moss promoting her first range for Topshop in 2007. The glimpse of their idol posing in a shop window in a dress from her collection unsurprisingly saw fans flock. The collection was a watershed moment in the history of high-street collaborations.

The model started her rise to style-icon status early. Here she is at a party in 1993 with Naomi Campbell. This image of Moss in a Liza Bruce slip dress and black pants, with a bare face and cigarette in hand, has become endlessly studied by designers. The aim? To bottle that nonchalant party-girl spirit.

88

AMY WINEHOUSE

With her signature beehive, eyeliner flicks, retro dresses and ballet flats, Amy Winehouse (1983–2011) was always going to appeal to the fashion industry. Equal parts mod, jazz singer, sailor and girl-group frontwoman, her musical influences extended to her image, with this heady mix as the result. Add her tragic story – which turns her from a personality to a pop-culture icon – and her place in the rock-'n'-roll fashion hall of fame was assured.

Although she died in 2011 aged only 27, Winehouse crammed a lot into her short life, and some of that involved fashion. She played a part in making Preen's 'Power' dress a hit. She wore the short, structured number – in a bright yellow – to the Brit Awards in 2007, where she sang 'Rehab' (2006) and picked up the gong for Best British Female Artist, putting the dress on the radar of a nation. With *Back to Black* the biggest-selling album of the same year, Winehouse was soon big news. A collaboration with Fred Perry followed in 2010, which proved successful with Winehouse's growing army of fans.

Her influence on high fashion is also notable. For Chanel's Pre-Fall Métiers d'Art collection shown in London in 2007, Karl Lagerfeld – always on the money when it comes to the zeitgeist – modelled his collection, all beehives and eyeliner, on Winehouse. Jean Paul Gaultier followed suit in 2012. Just months after her death, the designer dedicated his couture show to her. Clothes included pencil skirts, short blouson jackets and – of course – those beehives. Winehouse would have approved.

Winehouse in profile in 2007 was a sight to see – that beehive alone created a distinctive silhouette. Add the slick of eyeliner, an armful of tattoos and manicured nails, and here was a mix of ladylike and cool all at once. The bigger picture? A new take on punk that was uniquely hers.

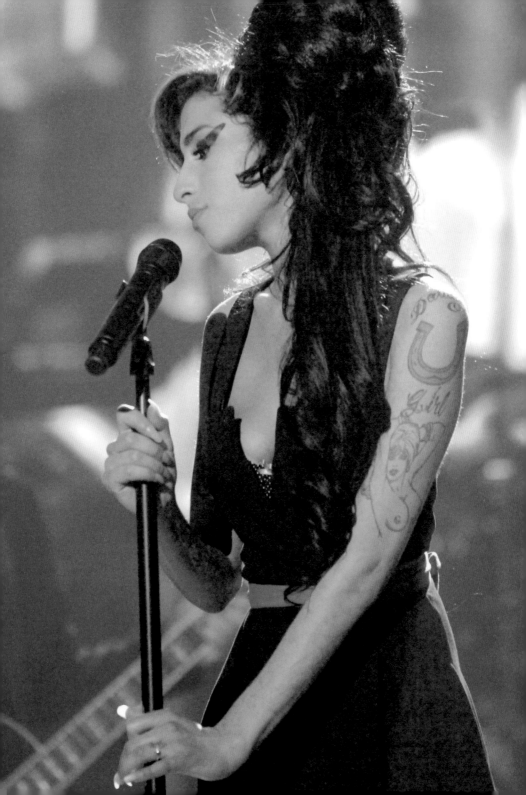

ANNA PIAGGI

When fashion editor and stylist Anna Piaggi (1931–2012) died aged 81, tributes poured in from the great and the good of the fashion industry. Shoe designer Manolo Blahnik created an event in her honour at London Fashion Week; milliner Stephen Jones curated an exhibition. Among the many words dedicated to her memory, *W* magazine's summed her up: 'In the realm of fashion exotics,' wrote Diane Solway, 'Anna Piaggi was the rarest of them all.'

Born in Milan, Piaggi began working as a fashion editor for Italian magazines in the 1970s and was creative consultant at *Vogue Italia* from 1988 until her death. But it was her own style that turned her from editor into fashion legend. Outfits were eye-catching and featured bright colours (sometimes in her hair), clashing patterns, a hat, a cane and a dot of shocking-pink rouge on each cheek.

Piaggi famously claimed that she had never worn the same outfit twice in public, and she certainly had the collection to make sure that this was never necessary. She loved the designers Zandra Rhodes, Ossie Clark and Kenzo but wore their pieces with finds from a military store or a Croatian market. Her archive was displayed at London's Victoria and Albert Museum in 2006, for the *Fashion-ology* exhibition dedicated to her. The archive was extensive – numbering nearly 1,000 hats and close to three 3,000 dresses.

Karl Lagerfeld said that 'Anna invents fashion' and he was, as usual, quite right. The stylist's legacy will partly come from her *doppie pagine* (double-page spreads) in *Vogue Italia* made up of collages of photographs and artworks relevant to the trends of a season. But the editor was also like a walking, talking, joyfully eccentric fashion shoot. If the front row is now full of peacocks, she was the pioneer.

Piaggi at an art opening in 2009, with enough pink to make Barbie jealous. Here, her pink hat, scarf and jacket happily clash with her blue eyeshadow and yellow Louis Vuitton handbag. Piaggi aimed to make each outfit a memorable one and she certainly succeeded here.

MICHELLE OBAMA

Even before her husband entered the Oval Office in January 2009, Michelle Obama (1964–) had been tipped as the First Lady of Style. Commentators will have been pleased to see that their prediction came to pass – Michelle has reigned supreme when it comes to political style. The true reach of her influence was acknowledged when she appeared on the cover of American *Vogue* in 2009, becoming only the second-ever First Lady to do so (Hilary Clinton was the first in 1998).

Obama walks a delicate balance, choosing clothes that manage to feel appropriate for someone under the scrutiny of the global spotlight, relevant to the fashion industry, relatable to women everywhere and – crucially – a whole lot of fun. Whatever the event might be, she will usually be found wearing colour, bold jewellery, a belt and, often, a cardigan and flats. It is practical elements like these last two that endear her to her public. She even wore a cardigan to meet Queen Elizabeth II.

Obama's fashion choices are her own, but she has advice from White House aide Meredith Koop. As well as her favourite brand, J.Crew, she has supported relatively new – and sometimes obscure – American designers, wearing Jason Wu to both Inauguration Balls (in 2009 and 2013), and Thom Browne (better known for his super-skinny menswear) at the second Inauguration Ceremony. Each occasion raised the designers' profile, with the Michelle Obama effect prompting an extensive 2012 article in the *New York Times* detailing brands that are now on the radar of retailers, thanks to Obama endorsing them. It seems likely that her influence on our wardrobes will be a lasting legacy.

As the expressions on these schoolgirls' faces attest, Obama is a bit of a heroine to a whole generation of young women. They no doubt appreciate her style, as well as her all-round awesomeness. This 2009 outfit – a full skirt, J.Crew cardigan, pearls and shoes of a sensible height – is pretty typical, and pretty stylish too.

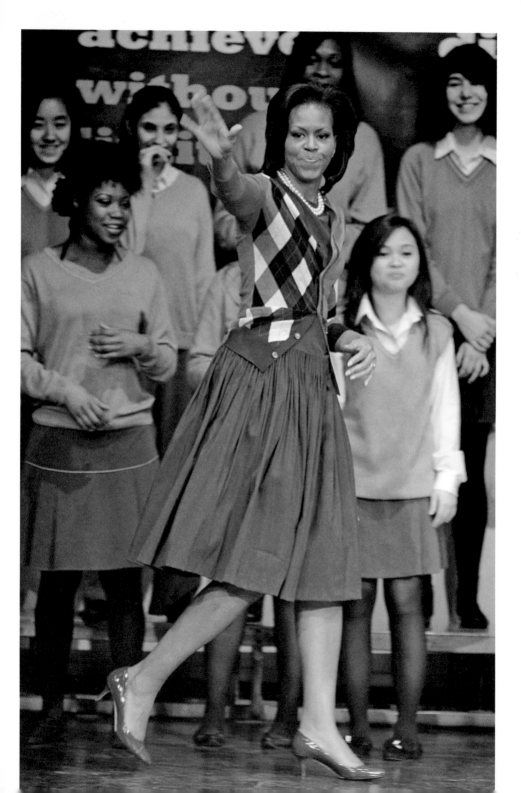

ALEXA CHUNG

It is not often that a television presenter can claim bona fide fashion credentials but Alexa Chung (1983–) has transcended her beginnings on Sunday-morning-hangover television. Long watched for what she wears, she has turned that gaze to her own advantage, by designing clothes and make-up, working as a fashion model and writing for *Vogue*. In 2013 she published a book, *It*, somewhat archly named in honour of the 'It Girl' tag that is frequently attached to her name.

The Chung formula consists of denim, tousled hair, winged eyeliner flicks, short hemlines and something of a 1960s influence. The former teen model gradually became a fashion player in the late 2000s, when she was co-hosting weekend-morning UK television show *Popworld* and dating Alex Turner, frontman of indie darlings the Arctic Monkeys. Her year was 2009 – she was named *Vogue*'s best-dressed woman and Mulberry named the 'Alexa', a satchel-type handbag, in her honour. Chung wore it around town, it became a bestseller and she began to work for brands ranging from Longchamp to AG Jeans. Somewhat inevitably, she has been called 'the new Kate Moss'.

Like Moss, Chung's appeal has much less to do with these advertizing gigs than with her personal style and genuine – seemingly, at least – flair for fashion. She takes risks with her clothes but, more often than not, she is on the money. While recent vogues for Peter Pan collars and dungarees can be put down to her influence, the definitive example is her haircut, now known simply as 'the Alexa' at salons across the UK.

Chung may have several style penchants, but it is not often that they are all seen in one image. When she was photographed at a 2011 film premiere in New York, the stars aligned: she is pictured in a short, 1960s-inspired dress, with a Peter Pan collar and that tousled haircut so admired by young women around the world. Check, check and check.

SHEIKHA MOZAH

There are not many women in the world who could claim to be Kim Kardashian's style icon. But Sheikha Mozah (1959–), the former First Lady of Qatar, has been hailed as such. In 2015 the *Guardian* compared the two women, with Kardashian's penchant for long lengths, flawless make-up and neutral colours described as 'classic Mozah power dressing'. If the multitudes are emulating Kardashian, those in the know have sidestepped the reality television star and are studying Mozah instead.

As the First Lady from 1995 to 2013, Mozah represented a new era for the oil state. She was described in a leaked US diplomatic cable as a 'fashionable "movie star" who, in the eyes of most Qataris, is the force behind the rapid pace of change that now permeates Qatari life'. She quickly caught the eye of the fashion world, with Julien Macdonald comparing her to Jackie Kennedy Onassis, when she visited the UK in 2010.

Mozah has been said to represent a 'soft power' within the Qatari government. She attends meetings with world leaders and works with the education-based Qatar Foundation. In terms of style, her reach comes from a clever way of reworking trends for clothes that fit within Muslim codes of modesty. Her skirts are floor length, her arms are covered and she wears a turban headdress, but outfits within that framework reflect fashion's current preoccupations. Favoured designers include Christian Dior, Chanel, Armani and Valentino. Augmented with immaculate contoured make-up, Mozah is the complete package. Kardashian – and her followers – continue to watch and learn.

If official visits for most royals involve low-key clothes designed for practicality and diplomacy, Mozah is different. Her immaculate outfits are always appropriate but they make her stand out. This one, worn in 2011 in Madrid, is a perfect example. A vision in cream, Mozah, together with her style credentials, is flawless.

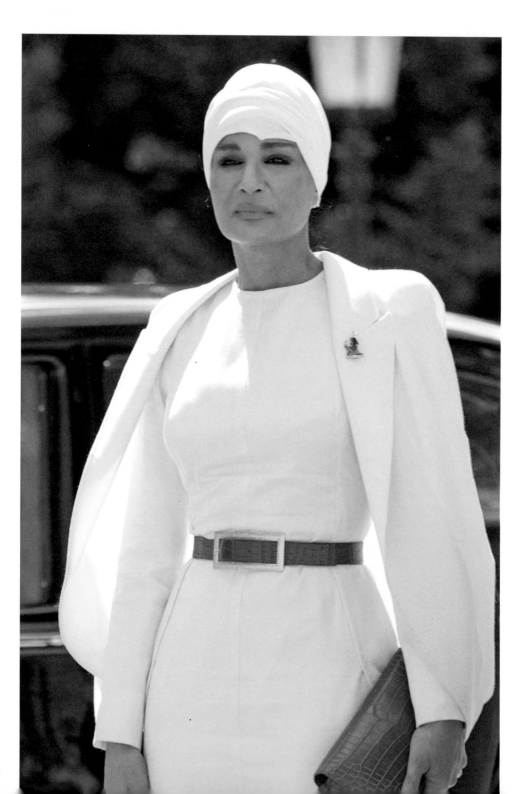

LADY GAGA

Lady Gaga (Stefani Germanotta; 1986–) has worn the work of all of fashion's household names but her position as a fashion icon for the 2000s can be traced back to a far less famous one – that of Franc Fernandez, the creator of the infamous meat dress that Gaga wore to the MTV Video Music Awards in 2010. This dress – constructed from flank steak and accessorized with diamonds – is so notorious that it prompted the animal rights organization PETA to release a statement damning it, and *The Simpsons* to parody it in cartoon form. The dress was displayed in the Rock and Roll Hall of Fame in 2011.

Such extremes are all part of the Gaga school of dressing. She has worn a dress made of plastic bubbles, one made of lace that covered her face as well as body, and another constructed from cuddly Kermit the Frogs. Her footwear is always a highlight – one pair of shoes was so impractical that her bodyguard had to carry her to a waiting car. While some artists limit this kind of dressing to performances, it's 24/7 for the woman whom fans call 'Mother Monster'.

In collaboration with former creative director of *Dazed & Confused* stylist Nicola Formichetti, she founded the 'Haus of Gaga', a Factory-like creative team, to put together her individual style. The great and the good of fashion have worked with the star. Gaga had a brief but clearly affecting friendship with Alexander McQueen, and she has said she is 'sad every day that I enter my closet' following the designer's death in 2010. Other close collaborators include Donatella Versace, Gareth Pugh and, most recently, Tom Ford. Gaga's love of fashion – like her career – continues apace.

Gaga is a woman who knows how to dress for an occasion. Here, in 2011, she appeared on Japanese talk show *Tetsuko no heya*. In tribute to the show's host's 'onion head' hairstyle, she wears an exaggerated updo and an onion-shaped dress. The black boots can perhaps be put down to Gaga's mood that day.

The 2010 iconic meat dress, which has to be seen to be believed. Gaga managed to increase the shock value even further with a back view exposing fishnet tights and the whisper of a thong. Add hair with blue streaks and hands dripping in diamonds, and that's a fashion moment.

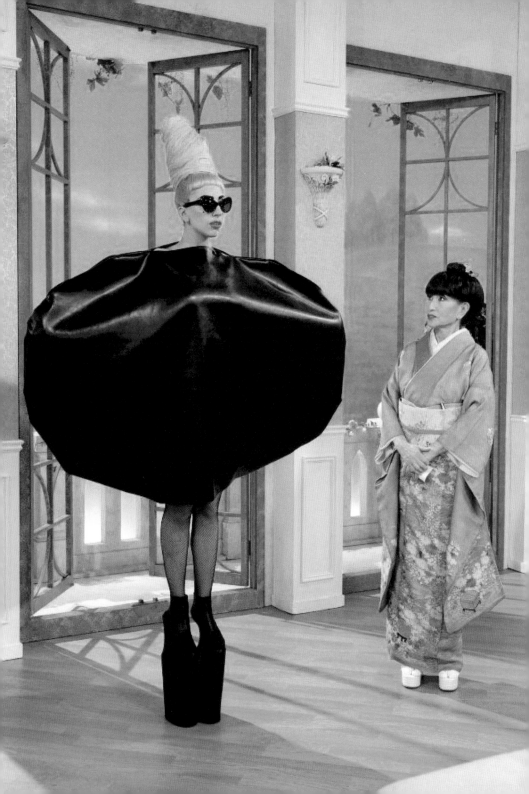

TILDA SWINTON

Playing Orlando in 1992 prophesied how Tilda Swinton's career would develop, and how clothes would be pivotal to it. The title character in Sally Potter's adaptation of Virginia Woolf's 1928 novel is – as a nobleman and then a noblewoman living through 300 years of history – understandably interested in dress. The costumes in the film, designed by Sandy Powell, cross gender and time but are routinely breathtaking.

Swinton has since made a name for herself as the thinking woman's style icon, partly because, with her androgynous beauty, she is light years away from the typical Hollywood starlet. But she is also fearless in an arena – the red carpet – that is renowned for being risk averse, wearing everything from Haider Ackermann satin to Prada prints and sculptural Christian Dior for film premieres. Her outfits, such as a 2008 black velvet asymmetric Lanvin dress, frequently cause controversy. No stranger to worst-dressed lists, these 'accolades' only endear the actor to her many fans.

The fashion industry, of course, loves anyone who dares to step outside the box – especially when such a trait is combined with otherworldly looks. Swinton has close relationships with the kind of designers, including Ackermann and Alber Elbaz, who have an insider following. She has also worked directly with brands, including Viktor & Rolf (who dedicated their Autumn/ Winter 2003 show to her) and Pringle of Scotland, a company close to her heart as a Highlands resident. Simon Doonan, creative ambassador-at-large for the iconic New York department store, Barneys, called her a 'fashion existentialist' but 'chameleon' may be more appropriate. Whether posing for stylist Edward Enninful as the late David Bowie in a shoot by Craig McDean for *Vogue Italia*, playing it deadpan in 2015 comedy *Trainwreck* or dressed in Elizabethan ruffs for *Orlando*, Swinton has represented an anything-goes spirit in fashion for three decades.

Swinton at her alien-like best. The actor, snapped at a Paris Fashion Week presentation, is demonstrating all the unusual flair that her fans watch her for. A satin blazer, oversized jewellery, swept-back hair and an inscrutable expression all help matters.

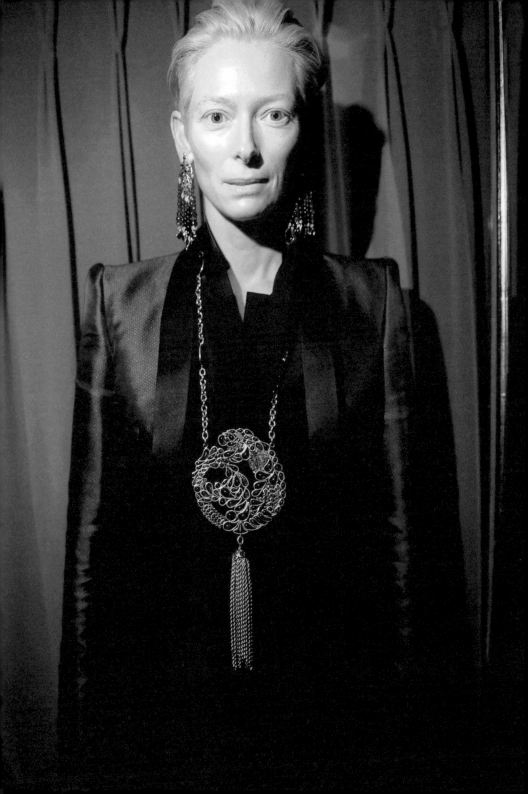

ANNA WINTOUR

It is a truth universally acknowledged that Anna Wintour (1949–), editor-in-chief at American *Vogue* and editorial director of Condé Nast, is the most powerful woman in fashion. Since 1988 the British-born editor has ruled the most-watched magazine in the world with a combination of foresight, determination and an ability to make the right decision quickly.

As someone who has been at the top of the fashion industry for almost 30 years, Wintour – whose schedule would probably make most government ministers balk – knows it is smart to find a look that suits her and run with it. For most of her time in the limelight, she has deviated very little from the formula of shift dress, bright colours, strappy mules, large dark shades and – of course – that bob. Starring in *The September Issue* in 2009, the documentary film about the creation of *Vogue*'s biggest issue ever (for September 2007), it also supposedly influenced the hairstyle of Edna Mode, the fashion editor in Disney Pixar's 2004 film, *The Incredibles*.

As her fame has increased, Wintour's bob has become the stuff of fashion legend. It can still be spotted on the front row of the most anticipated fashion shows. Reportedly kept immaculate during show season with a blow-dry in both the morning and early evening, it was immortalized in 2010 in a portrait by artist Alex Katz. The growing industry of Wintour merchandise should be noted, too. Her image can now be found on bag ornaments, phone cases and T-shirts. Wintour, now in her sixties, is no longer merely the most powerful woman in fashion – she is a fully fledged brand.

Wintour is a familiar sight in the front row of fashion shows. Fellow guests can recognize her out of the corner of an eye. If the bob, impenetrable expression and sunglasses do not catch their attention, the jewelled necklaces and penchant for updated ladylike glamour certainly will.

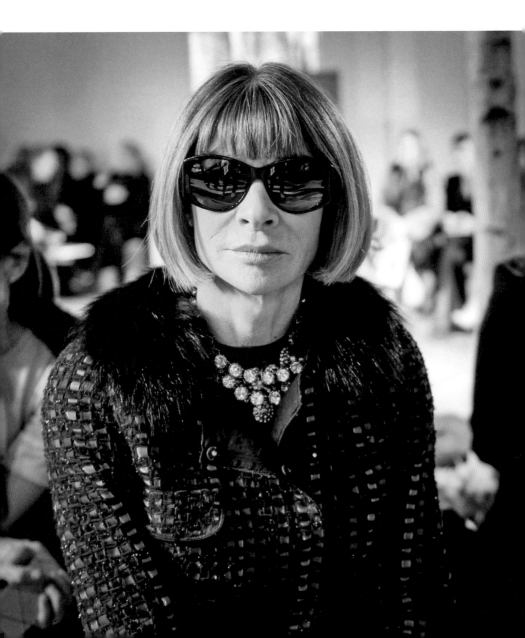

Described by photographer Helmut Newton as a 'fashion maniac', Anna Dello Russo (1962–) is the editor-at-large at *Vogue Japan* and a blogger. But her role within contemporary fashion is much broader than that. In the world of street style as seen outside fashion shows, she is Queen. The Italian-born editor was first photographed in around 2007 by Scott Schuman for his blog *The Sartorialist*, and her profile has since risen to almost pop-star levels, as is evident by the scrum she attracts for every post-show photo-op.

Dello Russo is certainly photo-friendly. She wears clothes straight off the runway, bright colours, statement hats and sky-high heels almost always. Her headpiece decorated with oversized cherries, designed by milliner Piers Atkinson, has become a trademark, while labels such as Moschino by Jeremy Scott, Balmain and Prada are favourites. During an average day at fashion week, she will change outfit several times. In 2010 'ADR' – as she is known in fashion circles – told the *Observer* that fashion was 'better than drugs'.

Far from letting this addiction consume her, Dello Russo has created a career out of it. Her blog, launched in 2010, has thousands of hits a day, and she has 175,000 Twitter followers. This influence led to a pop video for the song 'Fashion Shower' in 2012 and a collection of accessories for H&M the same year. The latter sold out in three hours. Dello Russo may be a fashion maniac but she is not alone. Described in 2015 by business magazine *Forbes* as 'fashion's most photographed woman', Dello Russo is now one of the most watched faces of the industry.

Two snaps are hardly enough to show the diversity of Dello Russo, but they will have to do. Photographed outside fashion shows in 2014 and 2015, she is shown wearing a Sacai cape with the kind of tassels that guarantee a good photo-op (top) and a full look designed by Jeremy Scott for Moschino (bottom). Dello Russo is nothing if not a street-style professional.

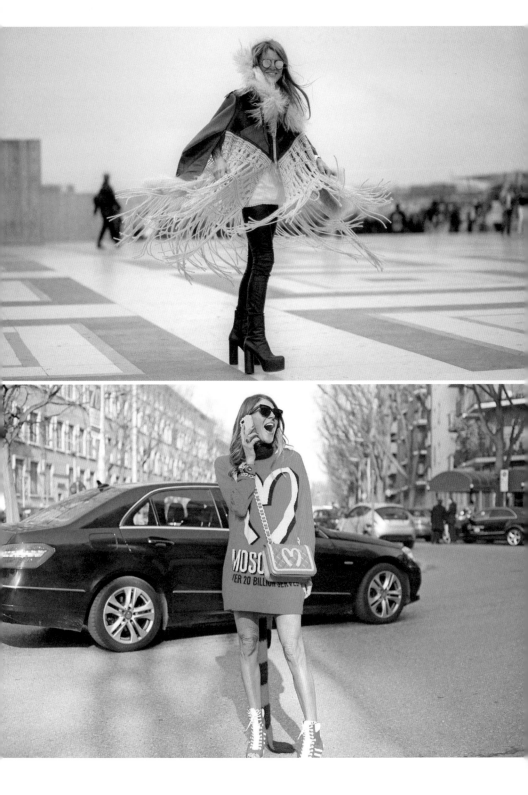

INDEX

PICTURE CREDITS

CREDITS

To Omi, a style icon if ever there was one.

An Hachette UK Company
www.hachette.co.uk

First published in
Great Britain in 2016
by Conran Octopus,
a division of Octopus
Publishing Group Ltd,
in conjunction with the
Design Museum

Octopus Publishing
Group Ltd
Carmelite House
50 Victoria Embankment
London EC4Y 0DZ
www.octopusbooks.co.uk
www.octopusbooksusa.com

Copyright © Octopus
Publishing Group Ltd 2016

Distributed in the US by
Hachette Book Group
1290 Avenue of the
Americas, 4th and 5th Floors,
New York, NY 10020

Distributed in Canada by
Canadian Manda Group
664 Annette St., Toronto,
Ontario, Canada M6S 2C8

A CIP catalogue record
for this book is available
from the British Library.

Text written by:
Lauren Cochrane

Commissioning Editor:
Joe Cottington
Consultant Editor:
Deyan Sudjic
Senior Editor:
Alex Stetter
Researcher:
Rio Ali
Copy Editor:
Robert Anderson
Design:
Untitled
Picture Researcher:
Giulia Hetherington
Production Controller:
Allison Gonsalves

Printed and bound in China
ISBN 978 1 84091 727 7

10 9 8 7 6 5 4 3 2 1

The Design Museum is one of the world's
leading museums of contemporary design.
Design Museum Members enjoy free
unlimited entry to the museum's outstanding
exhibitions as well as access to events, tours
and discounts. Becoming a Member is an
inspiring way to support the museum's work.
Visit designmuseum.org/become-a-member
and get involved today.